Norman Rockwell's
WORLD WAR II
IMPRESSIONS FROM THE HOMEFRONT

Susan E. Meyer

Foreword by Robert F. McDermott

USAA Foundation

A Roundtable Press Book

Grateful acknowledgment is made for permission
to reproduce the copyrighted material on the
following pages:

© Curtis Publishing Co., pages 6, 7, 8, 9, 10, 11,
13, 15, 17, 19, 21, 23, 25, 27, 29, 31, 33, 35, 43,
45, 47, 51, 53, 55, 57, 59, 61, 63, 65, 69, 71, 73,
75, 77, 79, 81, 83, 87, 89, 91, 93, 95
© Brown & Bigelow, pages 39, 67

Front cover image: *The Long Shadow of Lincoln*,
original oil painting for *Saturday Evening Post*
story, reproduced courtesy Curtis Publishing Co.,
collection The Lincoln Memorial Shrine and
Museum in Redlands, photo courtesy United
Services Automobile Association.

Back cover image: *Homecoming Marine*, original
oil painting for *Saturday Evening Post* cover,
reproduced courtesy Curtis Publishing Co.
collection American Illustrators Gallery/Judy
Goffman Fine Art, photo courtesy American
Illustrators Gallery/Judy Goffman Fine Art.

Drawings in Introduction: Story illustrations for
"A Night on a Troop Train," *Saturday Evening
Post*, May 8, 1943, photos courtesy The Norman
Rockwell Museum at Stockbridge.

Printed in United States of America

Library of Congress Catalog Card Number:
91-66989
ISBN 0-9631011-0-2

Contents

Preface

The illustrations reproduced here were selected from the pictures Rockwell created between the years 1941 and 1945 (plus one picture from 1946), illustrations that related directly or indirectly to the war. Wherever possible, the illustrations have been reproduced directly from the original oil paintings, rather than from the tearsheets, in order to obtain the best possible reproduction of the artist's work.

The commentary on the pictures derives from research that I performed for my book *Norman Rockwell's People*, published in 1981 by Harry N. Abrams, and from the issues of the *Saturday Evening Post* in which the illustrations first appeared.

Rockwell did not make a habit of titling his work. He referred to a picture simply as the "April Fool's cover" or the "Thanksgiving picture," for example. The titles given here, while necessary for clarity, are not necessarily consistent with those appearing in other published sources, although I have favored the titles used in the two-volume *Norman Rockwell: A Definitive Catalogue*, published by the Norman Rockwell Museum at Stockbridge in 1986. In one instance I discovered that a painting generally called *Listening for the Invasion of D-Day* was in fact painted several months before the actual event occurred, and so I have called the picture *War News*, a title that has appeared in other sources.

Direct quotes by Rockwell are drawn from three sources: his autobiography, *My Adventures as an Illustrator* (Doubleday, 1960); *Rockwell on Rockwell* (Watson-Guptill, 1979); and *Norman Rockwell Illustrator* by Arthur L. Guptill (Watson-Guptill, 1946). Wherever possible I have included preparatory sketches and information about how Rockwell developed the picture because his creative process reveals almost as much about the artist as it does the picture. I have also presented anecdotes that illustrate Rockwell's gentle sense of humor, a quality that underlies everything in his life and in his work. If Rockwell's gentle and modest personality emerges from the text, I have succeeded in demonstrating that there is little division between the man and his art.

Foreword
by Robert F. McDermott

Norman Rockwell was a prolific illustrator whose work spanned two world wars and several decades. Yet in my view, his World War II era pictures were especially significant. Although Rockwell rarely painted war scenes, he recorded feelings about the war and reactions to the war. In so doing, he spoke volumes.

Norman Rockwell painted the good that is universal in mankind: humor, loyalty, compassion for others, pride in country, and love of family. His pictures boosted the spirits of people in the 1940s and helped them keep the war in perspective. His illustrations reflected the principles for which the war was being fought while at the same time reminding Americans not to take themselves too seriously.

When a Rockwell illustration included soldiers, they were usually engaged in commonplace activities such as opening mail from home, enjoying leave, and feeding a hungry child. Perhaps his best pictures are those that chronicled life on the homefront while the war was waged across the seas. Whoever they were and whatever they were doing, Rockwell's subjects always seemed to be putting into practice the ideals of a free society. And while the illustrations in this book were very much a part of World War II America, many of them are still relevant today.

Why publish this book in the 1990s? One reason is to commemorate the fiftieth anniversary of the United States' involvement in World War II, and this would be justification enough. An even more important reason is to remind ourselves of the values embodied in Norman Rockwell's work—values America needs today. Love of family and country, compassion for others, respect, and humor all need more emphasis. I believe we would be better off as a nation if we placed a higher premium on these ingredients of life. To that end, this book presents some of Rockwell's finest pieces from the World War II time period. Although less well known than some of his other works, these illustrations deserve a much wider audience.

I have enjoyed Rockwell's work from my very first viewing. When I was a young fighter pilot in World War II, his pictures often reminded me of why I was in Europe. After many years as an educator and a businessman, I have come to appreciate him even more. My career has given me many opportunities to observe the importance of values such as love of family to people in all facets of life—students away from home, military people and their families serving around the world, and workers laboring to make ends meet. I watched some of these values fade over the years, particularly among our younger generations.

There is value to everyone in remembering World War II, when our nation pulled together with commitment and unity of purpose to oppose an external foe. Rockwell's illustrations of that era have worth for us today, too. His eternal optimism, his belief in the basic goodness of people, and his unabashed sentimentality refresh and inspire us now as they did in the 1940s.

Rockwell once said, "As I grew up ... I unconsciously decided that, even if it wasn't an ideal world, it should be so, and so I painted the ideal aspects of it." While the real world of today may not be as Rockwell painted it, his pictures provide us with a much-needed vision of what the world should be.

Introduction

From 1916 until his death in 1978, Norman Rockwell was America's favorite illustrator. This was no minor achievement, considering that until the mid-'40s illustrators commanded the kind of celebrity status now accorded to movie stars and sports heroes. Even after illustration was eclipsed first by photo-journalism and then by television as the primary means of reaching a wide public, Norman Rockwell continued to be a household name, and his images have become virtual icons of American life.

It's no surprise, then, that America's favorite illustrator was most directly associated with America's favorite magazine, the *Saturday Evening Post*. The *Post* was a publishing phenomenon. After 1897, when Cyrus H. K. Curtis bought the publication and hired George Horace Lorimer as its editor, the *Post* became the most successful family magazine in America, an institution in itself. Every week millions of subscribers pored over the articles by eminent writers and editors, and every week the magazine was flooded with impassioned letters from readers responding to what they had seen or read in the current issue. Illustrating covers for the *Post* was the greatest honor an artist could achieve, and Rockwell was the most honored of illustrators. Over the forty-seven years Rockwell was associated with the magazine, he created more *Post* covers than any other illustrator, a total of 322—an amazing feat when you figure that he was completing assignments for a multitude of other clients at the same time.

ROCKWELL'S WORLD

"The story of my life is, really, the story of my pictures and how I made them," Norman Rockwell wrote in his autobiography in 1960. "Because, in one way or another, everything I have ever seen or done has gone into my pictures." In fact, there is little division between the world in which he lived and the one he painted every day. The people in his pictures are his neighbors; the situations are those he observed around him.

During World War II Rockwell was living with his wife and three young sons in Vermont. Having moved

in 1938 from New Rochelle, a suburb of New York City, Rockwell and his family settled into the small rural community of Arlington, which would remain his home until 1953, when he moved to Stockbridge, Massachusetts. In Arlington Rockwell soon found himself in the company of several other illustrators and artists who, like himself, had escaped from the distractions of urban life. In particular he became close friends with Mead Schaeffer, a celebrated illustrator who also created covers for the *Post*, though in a very different genre. (Schaeffer, for example, preferred dramatic portrayals of adventure and heroic action, and he painted many combat subjects, which Rockwell rarely did.)

In Vermont Rockwell found the environment he needed to concentrate totally on his pictures, along with the quiet and stable schedule he required for painting. He was also surrounded by a community whose way of life closely approximated the scenes he painted, a rural town where living was more clearly rooted to the universal themes Rockwell sought for his illustrations.

Until Arlington, Rockwell painted from live models in the studio. He was obliged to use professionals who had the skill, time, and stamina to hold awkward poses for long hours. In Arlington Rockwell came to use the camera in his work, which meant he could now take photographs of his neighbors and use the photos for reference when he painted. "Now my pictures grew out of the world around me, the everyday life of my neighbors," he said. "I didn't fake anymore." The strong kinship Americans felt for the personalities depicted in Rockwell's work derived, in large part, from the authenticity of the subjects themselves; they were real people.

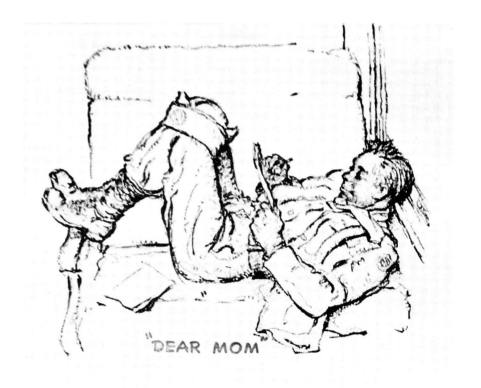

"DEAR MOM"

Rockwell was convinced that the success of any illustration lay in its truthfulness. In order to "bear the stamp of conviction," he said, "the subject and setting have to be real." To achieve realism meant attending to the painting with scrupulous attention to detail. He selected just the right model to convey the idea, a process that was more convenient in Arlington, where he could find every "type" he needed. He had an enormous collection of props in his studio, but if he lacked any, he assigned his wife, Mary, the task of hunting down precisely what he needed, maintaining that "there should never be anything shown in a picture that does not contribute directly to the telling of the story." Research was mandatory in the process: a uniform must fit according to regulations, bear the proper insignia, and be historically accurate.

Like the props, costumes, and models he selected, Rockwell's settings were also authentic. With the camera, he was no longer obliged to portray only the scenes he could construct in his studio. He was freed to photograph settings not accessible to him until then: a backyard in Troy, Benedict's garage in Arlington, the view from Middlebury College in Vermont.

Working with a photographer (he was never interested in taking pictures himself), Rockwell was the director, extracting the best performances possible from his models. Rockwell would pose himself first, give the expressions he was looking for, then request the models to do the same, encouraging them to make just the right gestures. Frequently he would do this over and over until the model struck exactly the right pose and the right facial expression. It was hard work. "In spite of occasional vagaries I couldn't ask for better models than my neighbors," he recalled. "Or more obliging ones. I put them through hell, asking them to assume (and hold) postures that would lay out a yogi, expressions which

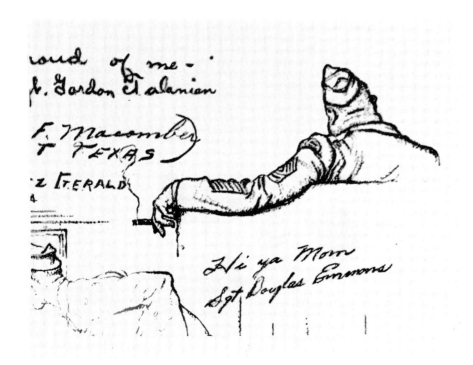

would exhaust a mime. And they do it happily, refuse to get mad. I don't know what I'd do without them."

After he had obtained all the photos of models, costumes, settings, and other details he might need for reference, he would tack the prints on the wall near his easel (there might be a dozen or more for a complicated composition) and make several preliminary studies in oil, charcoal, or pencil. From these he would develop a finished oil painting, by then working in white heat against an impending deadline. "Finally," he told his fans, "I wrap it up and send it in, and pray."

ROCKWELL'S PATRIOTISM

Allegiance to the nation is an idea that Rockwell would have described as "too high-blown," because it is so abstract. For him, the concept of nation was essentially synonymous with family or home. The principles for which the war was fought were not political concepts, but ideals that formed the substance of family life. When Rockwell set out to illustrate the "Four Freedoms," for example, the scenes he depicted were everyday occurrences, the models were his neighbors. The war was being fought to guarantee the individual's freedom of speech and worship and to protect the family from want and fear, all fundamental concepts central to a democratic civilization, all ideals threatened by totalitarian adversaries.

Rockwell was both an optimist and a humanist. The driving force in his work lay in his abiding faith in the goodness of human nature. He was incapable of being mean. Even when he poked fun at his subjects, he did so without derision. He was equally incapable of violence. Given these traits, and adding to this his apolitical nature, it is remarkable that Rockwell's images created during World War II somehow captured the spirit of a

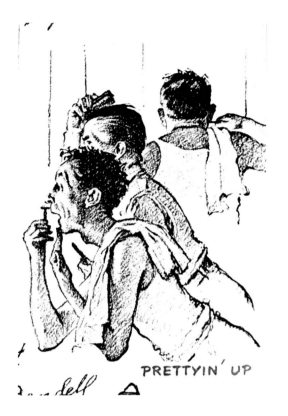

PRETTYIN' UP

nation at war in a way that no other body of work managed to accomplish. Because Rockwell sought themes that were universal, his illustrations touched a wide public during a period when the war affected every corner of American life. Americans recognized themselves in Rockwell's pictures even though these illustrations rarely referred to an event that related specifically to World War II. The scenes on the homefront, except for the garb or details of place, could have occurred during any war at any time in history. Conveyed in terms that are poignant and often humorous, Rockwell's illustrations of family life disrupted by war are timeless.

Even if Rockwell had wanted to illustrate a specific event, scheduling requirements would have prevented him from doing so. He generally worked on a *Post* cover three to four months in advance of publication, making it impossible to produce a truly timely subject. While the articles contained within the pages of the weekly magazine tended to be more topical, the covers never were. During the most intense years of the war, every newspaper and magazine featured stories of battles and destruction at the warfront. But at the *Post*, which contained regular features on the war and frequently published covers showing combat scenes, Rockwell continued to create what he did best: familiar scenes of life on the homefront. Although he inevitably painted a variety of GIs, he tended to show them in off-duty situations, not in battle. During the entire course of the war, in fact, Rockwell painted only one combat scene—a war poster showing a machine gunner who is running out of ammunition.

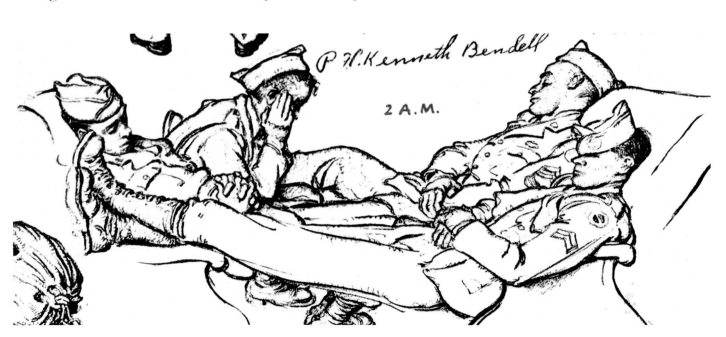

P.F.C. Kenneth Bendell

2 A.M.

Rockwell's own experience with the military was limited to his service in World War I, the details of which he relates with characteristic self-mockery in his autobiography. Confessing at the outset that he did not regard himself as a "fire-eater," Rockwell nevertheless made a sincere effort to serve his country even after he was declared exempt from the draft for reasons he failed to recall years later. He volunteered for Harbor Patrol to help guard the approaches to Fort Slocum, New York, a large enlistment center on an island just south of where Rockwell was living at the time. Once a week he and a friend sat up all night in a rowboat stocked with rifles, pistols, and knives, the two drowsy young men endlessly waiting for German submarines that never did surface on the choppy bay.

Then one day Rockwell beheld a group of wounded merchant seamen on the subway in New York City and

decided that he owed more to his country than one night a week in a rowboat. He immediately took a taxi to the nearest naval enlistment center. There Rockwell was dismayed to learn he was seventeen pounds underweight, but he had the good fortune to encounter a sympathetic and resourceful examining doctor. "We can waive ten pounds, but not seventeen," declared the doctor, prescribing an instant solution: "bananas, doughnuts, and water. You eat seven pounds' worth, we waive the other ten pounds, and you're in." From a large file drawer the doctor extracted a sizable quantity of bananas and doughnuts and served up a huge pitcher of water, all of which Rockwell consumed while the doctor puffed on his cigar and studied his patient's progress. Many massive helpings were ingested before Rockwell weighed in seven pounds heavier, but he tottered home a happy new recruit in the United States Navy.

Rockwell's image as the heroic sailor was tempered as soon as he put on his new uniform of bell-bottom trousers, tight blouse, and little white cap. "I looked like a toadstool turned upside down," he mused. The Navy wisely kept him out of combat ("I hardly knew the butt of a rifle from the barrel," Rockwell sadly admitted), exploiting instead his real talent for creating pictures. Rockwell was stationed at the naval base in Charleston for

the duration of his service, assigned to the camp newspaper, *Afloat and Ashore*, and happily painting portraits of the officers and other sailors. He was even permitted to do his own work as long as it related in some way to the Navy, so that during World War I Rockwell created a number of covers for the magazines to which he had been contributing before entering the service.

Rockwell recalled his time at the Charleston naval base with affection, pride, and humor. It was the first time that he found himself in close company with people whose life stories and backgrounds were dramatically different from anything he had experienced in his own. Nothing could have provided better material for his pictures or given him a better understanding of the men called upon to serve their country in a crisis.

ROCKWELL'S PICTURE IDEAS

For Rockwell, getting the idea was generally the hardest part of painting, coming up with something that "makes the reader want to sigh and smile at the same time." After all, the magazines in which his work appeared reached millions of readers, and finding a universal idea that would appeal to all of them could be tough indeed.

For Rockwell that problem vanished in wartime. All Americans, regardless of where they lived or what they had in common—the farmer, the city slicker, the housewife, the schoolboy—were thinking along the same lines. So it wasn't hard for Rockwell to arrive at an idea that they would all understand. What's more, he didn't have to wrack his brains for ideas because life had been

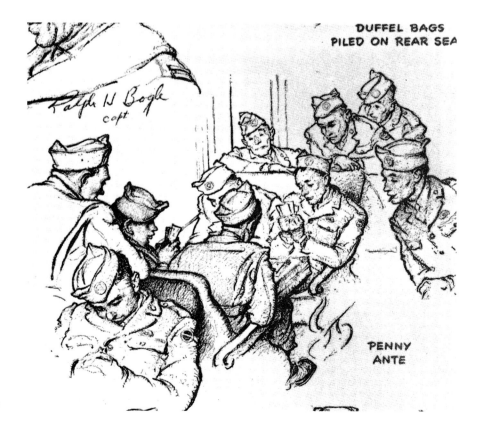

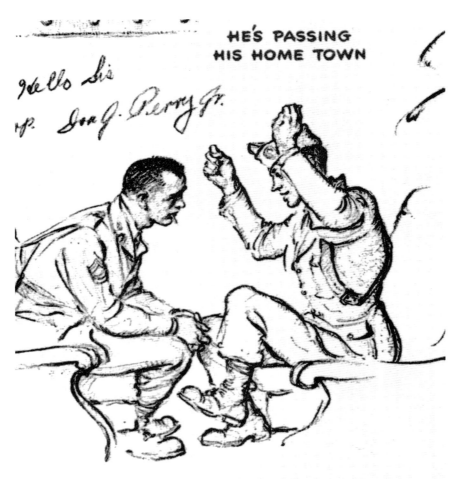

HE'S PASSING HIS HOME TOWN

TELLING ABOUT HIS FIRST JUMP

turned upside down anyway. "Men go off to war; women go to work; draft boards, rationing boards, bond drives; soldiers abroad . . . ideas dropping from trees, from the lips of babes."

Like other Americans, of course, Rockwell was preoccupied with the war, and regularly recorded his impressions in his work. Of the thirty-three *Post* covers he produced between 1941 and 1945, twenty-five related to the war in some way. Willie Gillis, a lovable young recruit invented by Rockwell, appeared eleven times on the cover of the *Post*, and Gillis's image was circulated widely through the USO as well. Several of Rockwell's wartime illustrations were designed for pure entertainment (a distraction that was warmly welcomed by the American public), and others offered a poignant view of the soldier's leaving home, missing home, traveling far from home, returning home. From stateside there were also recurring themes: supporting the war effort, staying current with the news, carrying on with the business of democracy.

Rockwell continued to be a prolific illustrator throughout the war, but the direction of his work had begun to change, becoming far more naturalistic. Several reasons account for this shift. Using the camera, of course, had freed him to create more varied poses, unusual

viewpoints, real settings with real models. Changes at the *Post* also stimulated new directions in his work. In 1942 the new *Post* editor, Ben Hibbs, revamped the editorial and graphics with a mind toward making the *Post* a more contemporary publication. Rockwell responded to the new design with enthusiasm, no longer silhouetting his figures against a flat background, but now painting scenes in detailed settings. Rockwell's search for accuracy stimulated him to document subjects of interest. On one occasion, for example, he recorded a visit to the ration board in Manchester, Vermont; on another occasion a visit to the election polls in the Midwest. Accompanying his friend Mead Schaeffer to an army base, he documented the paratroopers he saw on a troop train. These records are the work of an artist who insisted on getting every detail just right.

It was also during that war that Rockwell became haunted by another kind of illustration, the idea of the "Big Picture," a pictorial statement of universal meaning. During World War II, when he was searching his heart to understand the reasons for so much bloodshed and suffering, he was compelled to paint something that would remind everyone why the war was being fought. The "Four Freedoms" and *The Long Shadow of Lincoln* grew out of this quest.

In 1942, when victory seemed a long way off, Rockwell and his friend Schaeffer felt compelled to make a meaningful contribution to the war effort. Knowing that they were too old to enlist, they decided to create posters, but Rockwell simply couldn't arrive at an inspired idea that would instill a sense of hope. He had an idea to illustrate the thoughts presented the year before by Franklin Delano Roosevelt in the president's annual address to the Congress:

In the future days, which we seek to make secure,
we look forward to a world founded upon
four essential human freedoms.

The first is freedom of speech and expression—
everywhere in the world.

The second is freedom of every person to worship God
in his own way—everywhere in the world.

The third is freedom from want—which, translated
into world terms, means economic understandings which
will secure to every nation a healthy peacetime life
for its inhabitants—everywhere in the world.

The fourth is freedom from fear—which, translated into world terms, means a world-wide reduction of armaments to such a point and in such a thorough fashion that no nation will be in a position to commit an act of physical aggression against any neighbor— anywhere in the world.

This celebrated declaration of four freedoms, which was restated in the Atlantic Charter in 1941 by Roosevelt and Winston Churchill, seemed like the right place for Rockwell to start, but his first attempts at translating the words into pictures seemed too pretentious, until he was struck by an idea in the middle of the night while tossing and turning in his bed. He ran downstairs, jumped onto his bicycle, and rode over to Schaeffer's house to awaken his friend with the good news. The idea was to express the awesome concept of the four freedoms in simple, everyday terms, showing ordinary people in scenes we all take for granted. "Take the four freedoms out of the noble language of the proclamation and put them in terms everybody can understand," Rockwell explained.

Armed with his rough sketches, Rockwell presented his idea to several government offices, but failed to find one that would accept his offer. The *Saturday Evening Post*, on the other hand, was delighted to publish the "Four Freedoms" and Rockwell devoted the next six months exclusively to their execution. "The job was too big for me," he confessed modestly. "It should have been tackled by Michelangelo." The reception to the publication of the "Four Freedoms" in 1943 was immediate and overwhelming. Requests came pouring in for reprints. Then the government finally joined in, distributing millions of reproductions in connection with its war-bond drive. The originals were sent on an exhibition tour of sixteen cities to help sell war bonds, and the exhibitions were viewed by more than 100 million people, raising nearly $150

DUFFEL BAGS
PILED ON REAR SEATS

million in war bonds. Eventually the Office of War Information circulated posters abroad and to public buildings throughout the nation. These four paintings became the best-known images of the era, arriving at a time when Americans urgently needed an inspiring statement of hope.

In 1945, as the war was nearing its end, Rockwell painted another Big Picture, to *The Long Shadow of Lincoln*. Here he drew a parallel between the principles for which Lincoln stood and those for which the war was being fought so many years later. After the painting was reproduced in the *Post*, Rockwell donated it to the Lincoln Memorial Shrine in Redlands, California, where it hangs today. It remains a tribute to the president and a lasting memorial to those who made so many sacrifices to build a better world for future generations.

Reviewing the pictures Rockwell created during World War II, we see clearly that he made a greater contribution to the war effort than he would have admitted to himself. From the playful foibles of Willie Gillis, to the posters urging Americans to support the cause, to the moving symbols of liberty in the "Four Freedoms," Rockwell's work stands as an eloquent expression of the principles of a strong and noble nation.

Willie Gillis

After the first draft call, but before Pearl Harbor, Rockwell planned a series of *Saturday Evening Post* covers about one soldier, a quiet, lovable young innocent who could be anyone's son or kid brother. For a model, Rockwell wanted someone likely to remain in Vermont for the entire series, and at a local square dance he happened to land on the ideal candidate: Robert Otis Buck, who had been exempted from the draft because of stomach surgery performed some time before.

Rockwell went to Fort Dix in central New Jersey to study the uniforms his subject would be likely to wear. He also bought a complete GI outfit, "from boudoir blues to the ballroom browns," which he intended model Bob Buck to wear on every occasion.

The first cover in the series presents a newly drafted soldier receiving a package from home. Needing a name for the address label on the package, Rockwell consulted his wife, Mary, who came up with the name "Willie Gillis" after thinking of a book she had read to the children called *Wee Willie Winkie*. Attentive *Post* readers pointed out that the Gillis package from home showed insufficient postage, and from then on Rockwell weighed in his packages and letters at the post office before he painted any stamps—an important detail since so many of Rockwell's wartime covers included mail to and from home.

When Rockwell planned this series, he didn't anticipate that there would be so many covers related to the war. The ten Willie Gillis covers that followed this one represent a running narrative of the war years as seen through the experiences of Willie Gillis and those who loved him.

WILLIE GILLIS: FOOD PACKAGE
Saturday Evening Post cover
October 4, 1941
Photo courtesy The Norman Rockwell Museum at Stockbridge

THE SATURDAY EVENING POST

Oct. 4, '41
VOL. 214. NO. 14

Fou in

5 cts.
7c. IN CANADA

FOOD
NO DELAY!

Norman Rockwell

DEFENSE
WITHOUT END
By GARET GARRETT

CARDINAL O'CONNELL By JACK ALEXANDER

The reception to the first Willie Gillis cover was so great that Rockwell immediately set about doing the next. He continued the series with a theme that recurs frequently throughout the war: coming home. Only a month after the first Willie Gillis cover, and still before Pearl Harbor, Rockwell brings his favorite private home on leave. From the very outset, Rockwell reminds us that the heroes defending the nation are still everyday people who want to come home to their loved ones, to a country at peace.

WILLIE GILLIS: HOME SWEET HOME
Saturday Evening Post cover
November 29, 1941
Photo courtesy The Norman Rockwell Museum at Stockbridge

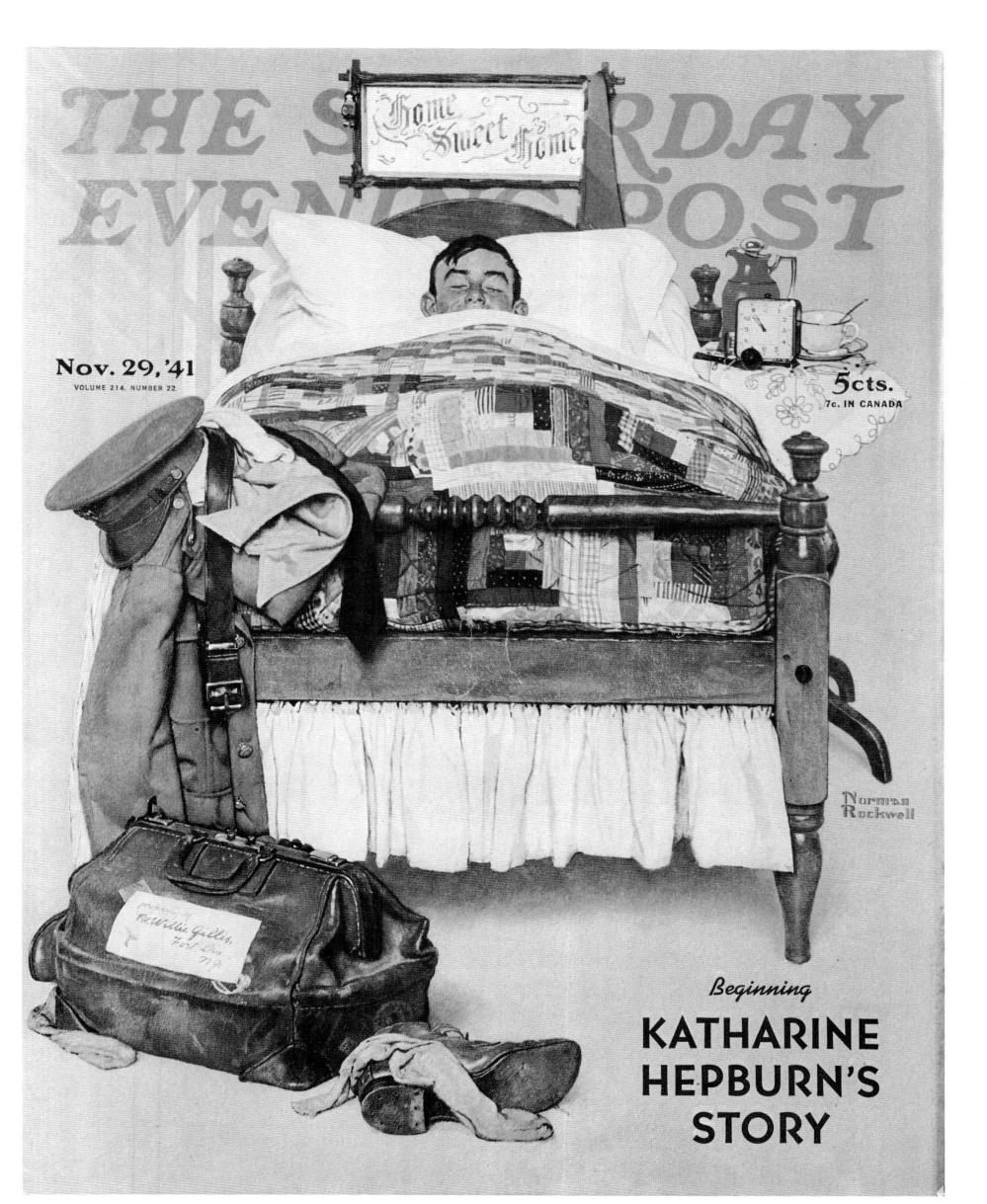

Ministered by two stunning volunteers from the USO, Rockwell's innocent war hero is off to a great start. Here the artist introduces another recurring theme: the soldier engulfed by the new experiences he encounters away from home. Through Rockwell's telling, these experiences are poignant, often humorous, but never nasty.

By now Willie had become a favorite with the *Post* readers (and the first two oil paintings in the series were already hanging in the Fort Dix New Service Club Library on loan from the artist). Rockwell started on the third image just before leaving for a change of scene in California. He made sketches of Bob Buck, then completed the painting on the West Coast, where he hired two female models, the blonde having been selected by the Navy as one of the six most beautiful women in Hollywood.

WILLIE GILLIS: USO
Saturday Evening Post cover
February 7, 1942
Photo courtesy The Norman Rockwell Museum at Stockbridge

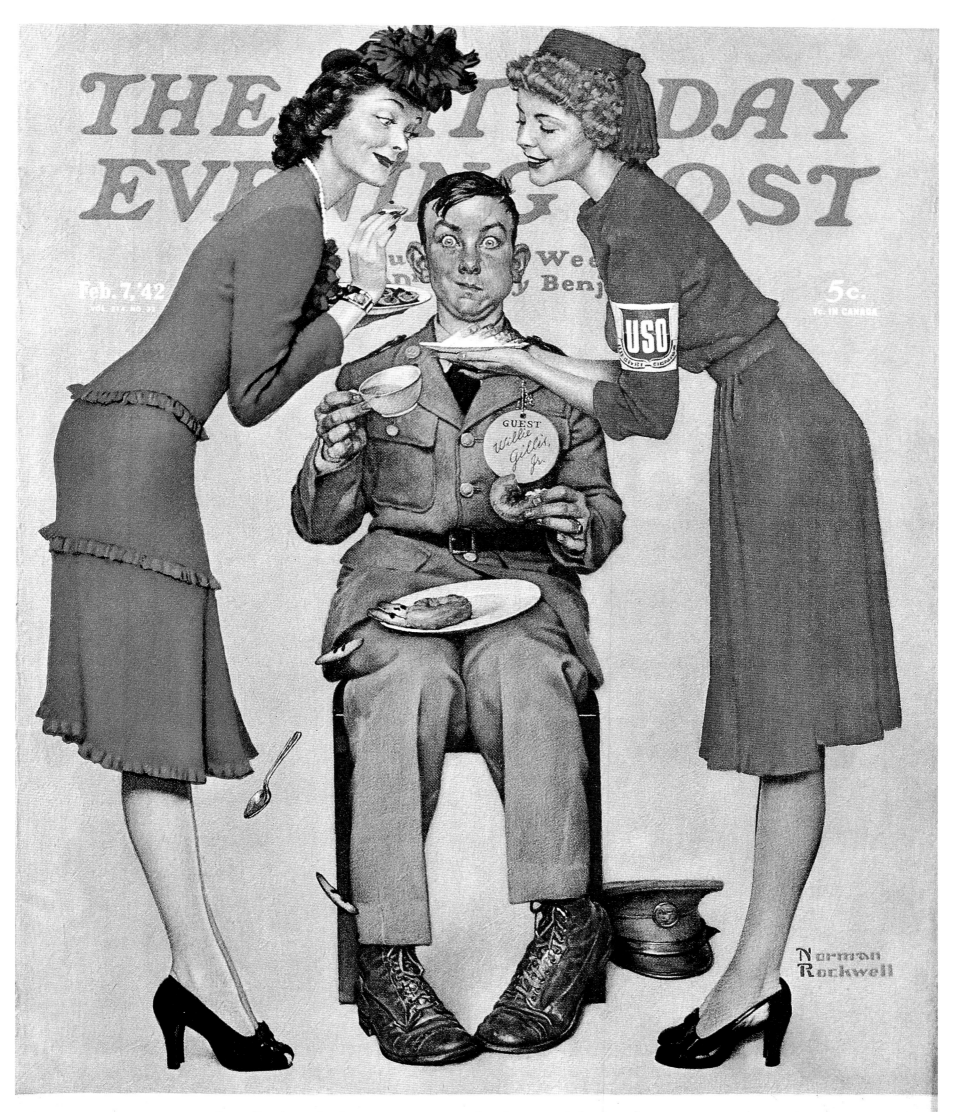

First of **C. S. FORESTER'S NEW NAVY STORIES**

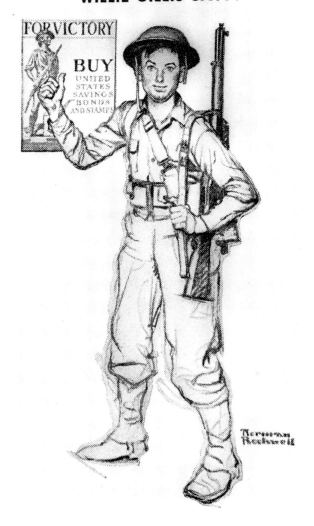

Willie Gillis Says: "For Victory Buy United States Savings Bonds and Stamps"

1942 U.S. Savings Bond advertisement
Saturday Evening Post
April 11, 1942
Whereabouts of original unknown
Photo courtesy The Norman Rockwell
Museum at Stockbridge

Being away from home could offer some marvelous new experiences, but more often than not home seemed very far away to the young recruit. Rockwell's portrayal of homesickness appears frequently during the war, reminding those at home of their significance.

By the time the United States entered the war, Willie Gillis had become a symbol of the American soldier, and throughout 1942 he appeared even more frequently. So popular had he become, in fact, that 2,500 enlarged reproductions of all Willie Gillis covers were being distributed by the USO to railway stations and to clubs located in the States and overseas. Willie Gillis was even selected to promote the sale of United States Savings Bonds.

WILLIE GILLIS: HOME TOWN NEWS
Original oil painting for *Saturday Evening Post* cover, 38" x 30"
April 11, 1942
Private collection
Photo courtesy American Illustrators Gallery/Judy Goffman Fine Art

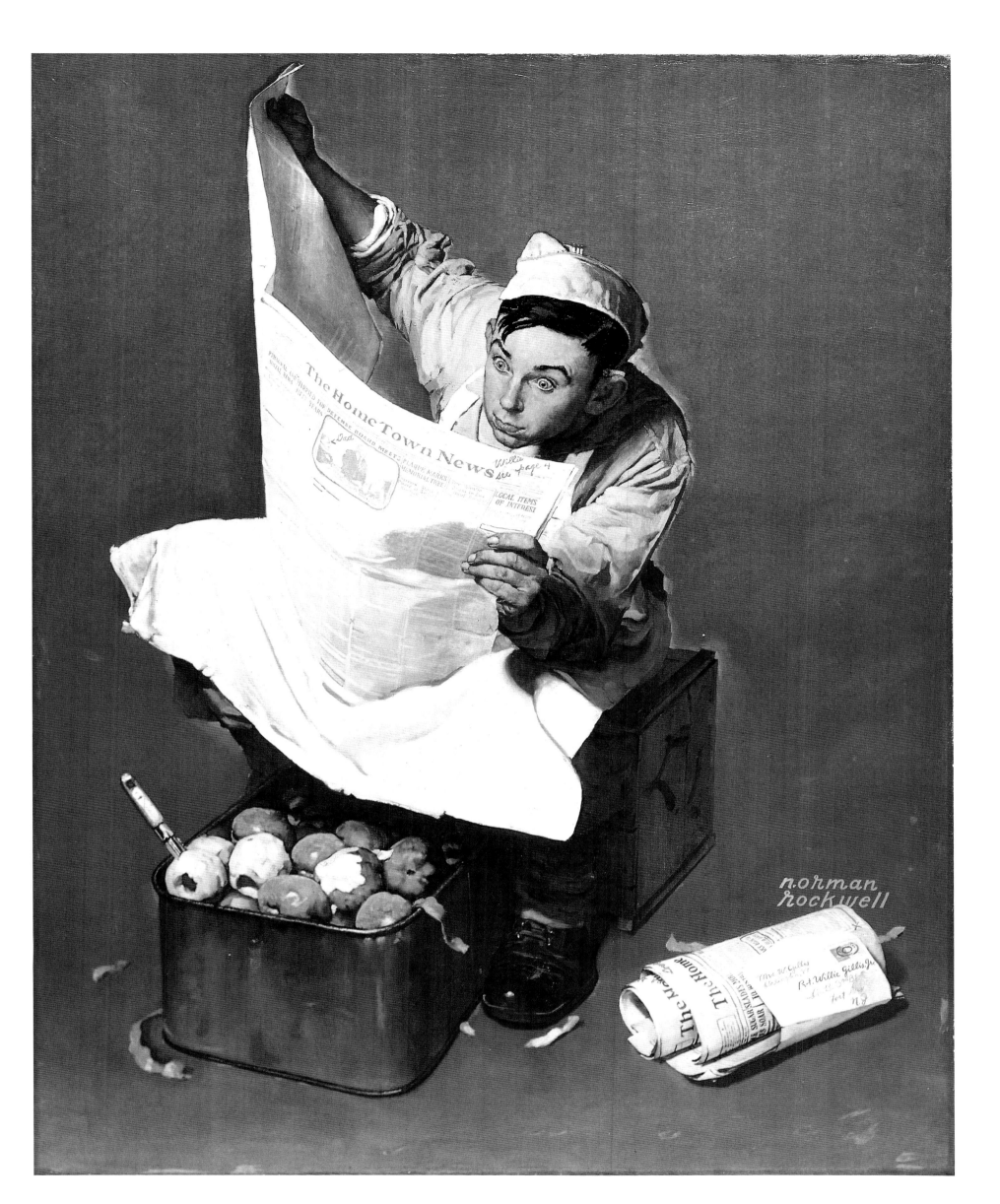

Charcoal on paper, 27" x 22½"
Collection American Illustrators Gallery/
Judy Goffman Fine Art
Photo courtesy American Illustrators Gallery/
Judy Goffman Fine Art

Rockwell was able to transform the frightening experience of a blackout into a playful excuse for fun. By tempering the fear of imminent bombardment with his light-hearted scene, Rockwell represented a reassuring voice to an American public poised for disaster.

This was the first cover that Rockwell prepared for the new, more contemporary design initiated by Ben Hibbs, who had recently become the editor of the *Saturday Evening Post*. With the new format Rockwell began to shift his approach somewhat, his settings gradually becoming more detailed and realistic.

WILLIE GILLIS: BLACKOUT
Saturday Evening Post cover
June 27, 1942
Photo courtesy Curtis Publishing Co.

THE SATURDAY EVENING

POST

JUNE 27, 1942

VOLUME 214 NUMBER 52

10¢

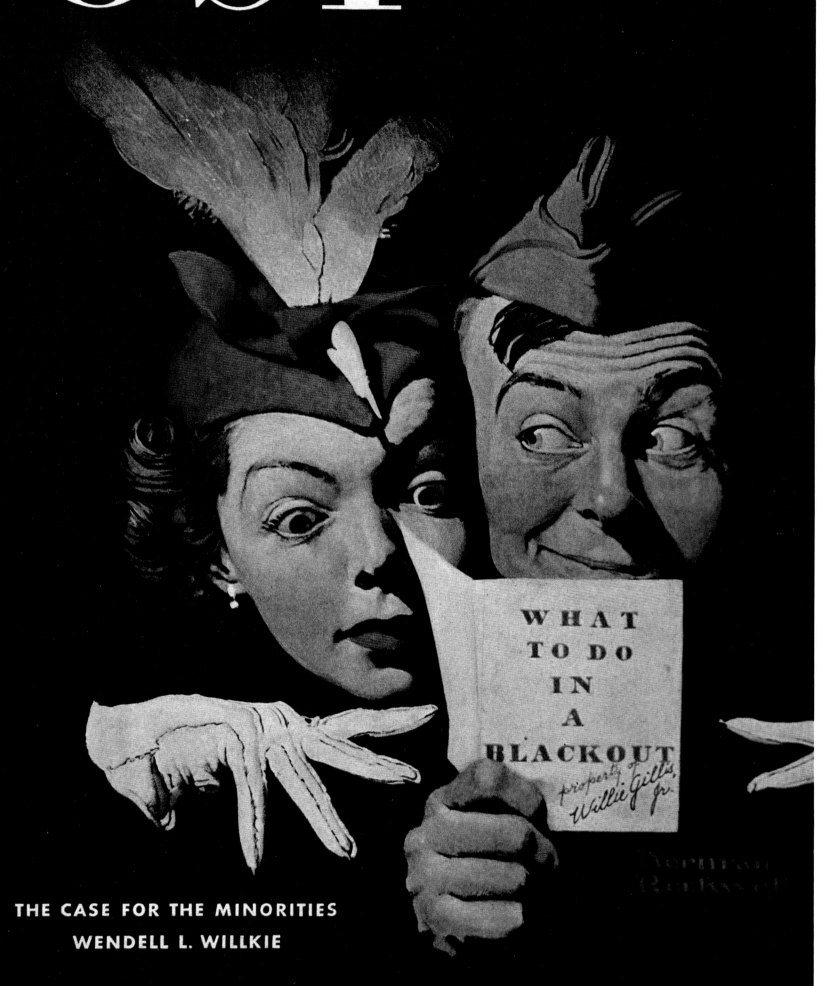

WHAT
TO DO
IN
A
BLACKOUT

property of Willie Gillis, Jr.

THE CASE FOR THE MINORITIES
WENDELL L. WILLKIE

OUR TWO MONTHS ON CORREGIDOR CABOT COVILLE

Charcoal on paper, 36½" x 33"
Collection American Illustrators Gallery/
Judy Goffman Fine Art
Photo courtesy American Illustrators Gallery/
Judy Goffman Fine Art

Willie Gillis provided Rockwell with a vehicle for expressing a wide range of sentiments that reflected the intensely emotional times in which Americans were living in the early 1940s. By mid-1942 Willie had become a familiar figure who inevitably evoked a smile of affection. Here Rockwell presents a more serious aspect of Willie's life as a soldier, a poignant reminder that what lies ahead is not all fun and adventure. While Willie is very much alone in his apprehensiveness about the future, Rockwell makes it clear that other men—regardless of rank or service—are also engaged in their private thoughts of what tomorrow holds.

WILLIE GILLIS IN CHURCH

Saturday Evening Post cover
July 25, 1942
Photo courtesy The Norman Rockwell Museum at Stockbridge

THE SATURDAY EVENING
POST

JULY 25, 1942 10¢

REA... ...ISSUE

A... ...
BLACK M... ...ET

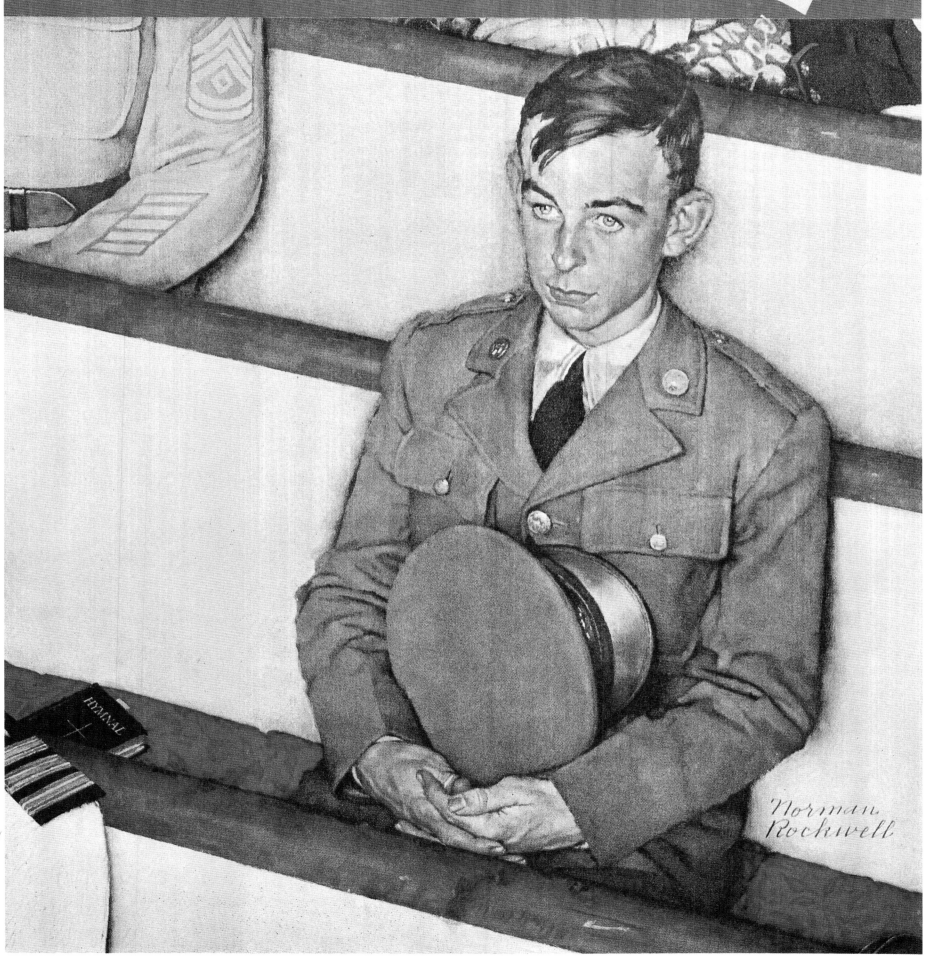

Norman
Rockwell

By mid-1942 Willie Gillis had become such a favorite with *Post* readers that he was the central attraction even when he was absent from the picture. We do not know what kind of hero Willie may have been on the battlefield, but we do know that he was a hero with women. The two women who are competing for Willie's affections are actually sisters, the daughters of Rockwell's good friend and neighbor, Mead Schaeffer.

WILLIE GILLIS: GIRLS WITH LETTERS
Saturday Evening Post cover
September 5, 1942
Photo courtesy The Norman Rockwell Museum at Stockbridge

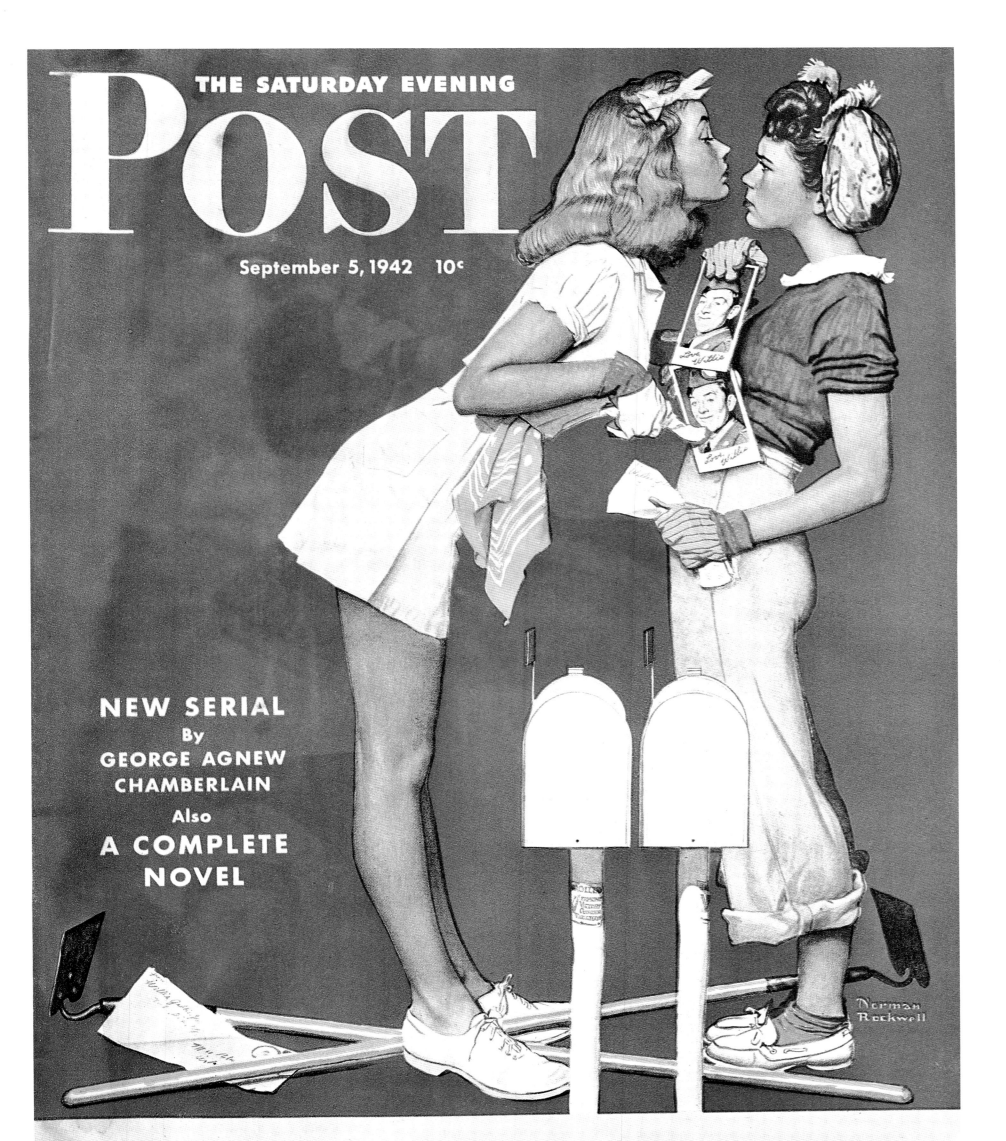

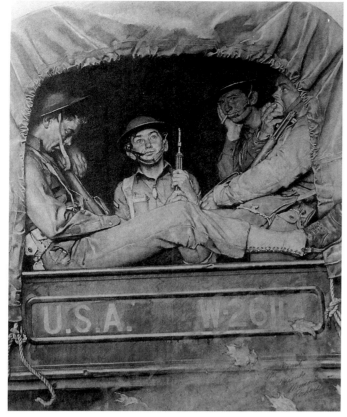

Willie Gillis in Convoy

Unused study for *Saturday Evening Post* cover
1943
Charcoal on paper, 41½" x 33¾"
Photo courtesy The Norman Rockwell Museum
at Stockbridge

With the news that the Allies were moving on the offensive in 1943, Willie Gillis began to shift gears. By now he was a more seasoned soldier, no longer the shy young recruit pining for home. Nevertheless, Willie remains a gentle warrior, playing cat's cradle with an Indian fakir or calmly smoking his pipe in the convoy truck. While the war was raging at a fierce pace, Willie Gillis never lost his humanity, a reassurance to those who worried about what was happening to their loved ones on the front.

WILLIE GILLIS: CAT'S CRADLE
Saturday Evening Post cover
June 26, 1943
Photo courtesy The Norman Rockwell Museum at Stockbridge

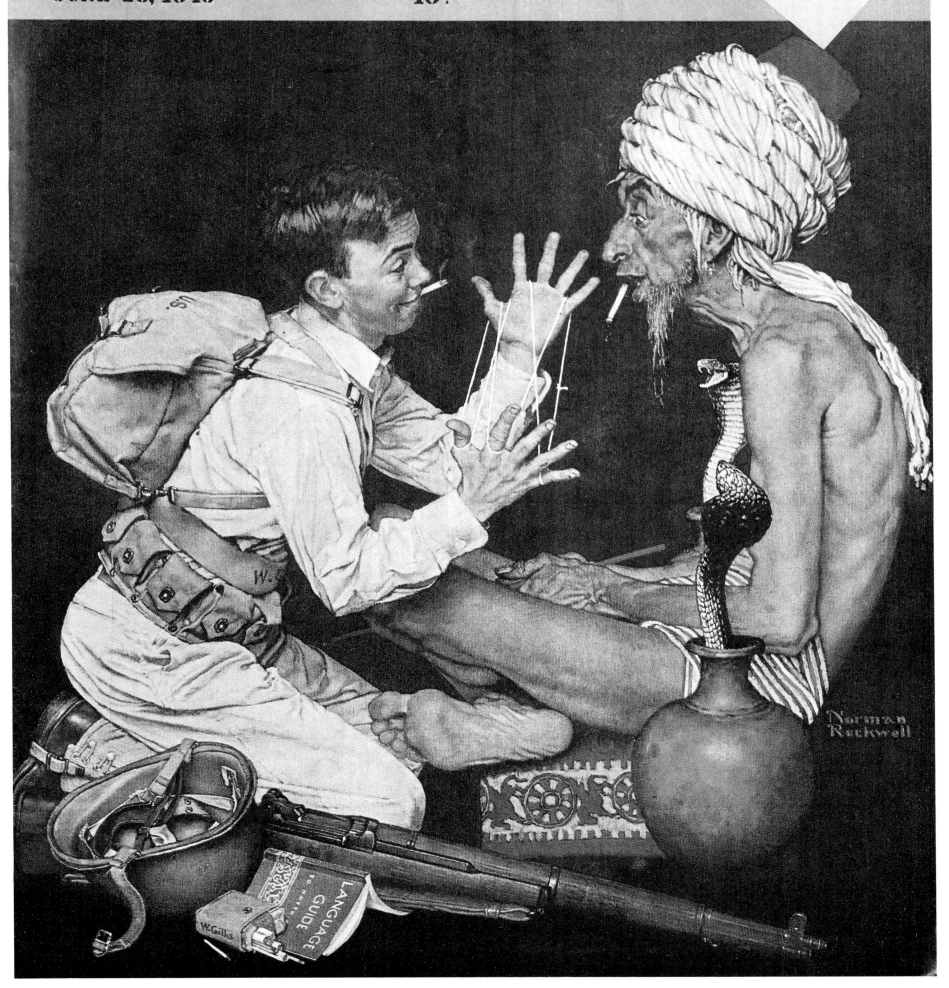

Although he had been exempted from the draft, Bob Buck felt he could not simply stay at home while a war was going on. To his dismay, Rockwell lost his Willie Gillis in 1943, when Buck enlisted as an aviator in the Navy. The *Post* reported on this turn of events by saying, "While Bob Buck was becoming one of the better-known Army figures because of Rockwell's pictures, Buck was riding Navy planes based in Los Alamitos, California, as an Aviation Ordnanceman, third-class." Lacking a real model, Rockwell was compelled to improvise if he wanted to keep the Willie Gillis series going. Referring to several head shots taken before Buck's departure, Rockwell placed portrait photographs on the wall above the bed where Willie's girl (Mead Schaeffer's daughter again) is sleeping through New Year's Eve.

WILLIE GILLIS: NEW YEAR'S EVE
Original oil painting for *Saturday Evening Post* cover
January 1, 1944
Whereabouts of original unknown
Photo courtesy The Norman Rockwell Museum at Stockbridge

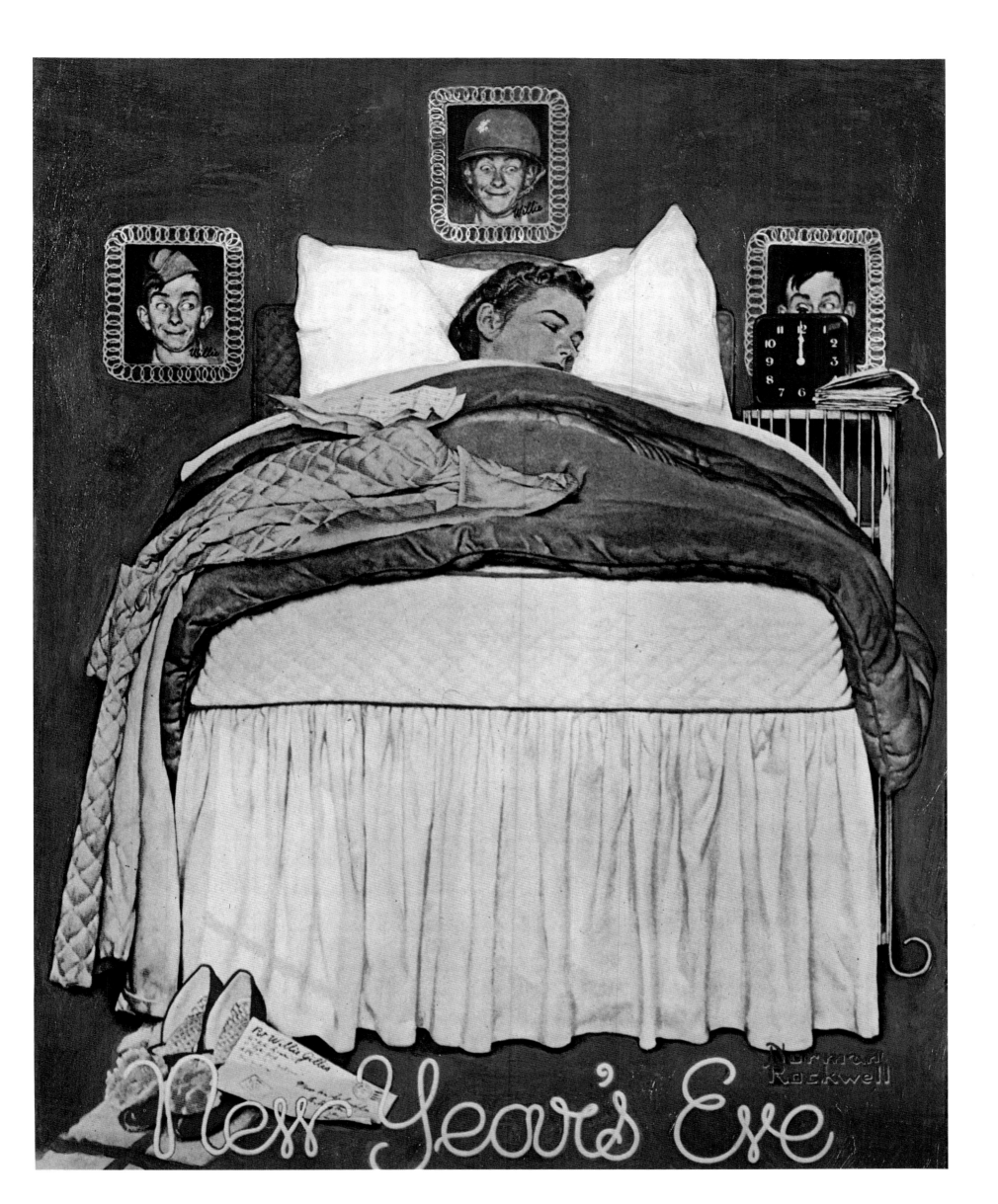

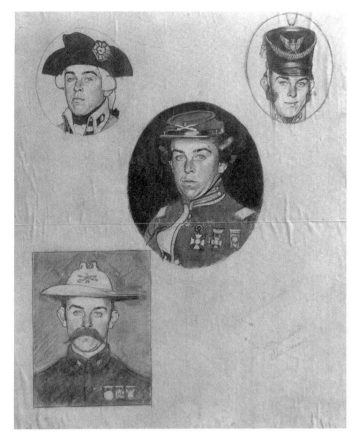

Charcoal on paper, 27¾" x 20"
Collection Ralph Gross
Photo courtesy The Norman Rockwell Museum
at Stockbridge

With Bob Buck off in the Pacific, Rockwell continued to use the head shots that he had taken before Buck's departure, creating six generations of fighting Gillises. Rockwell had a fine time with this trompe l'oeil still life and with the various kinds of head gear, carefully retaining the accuracy of the historical costumes. He fabricated a complete library of volumes documenting the military valor of the Gillis family, which attracted more attention than any other detail. "The cover was very popular," he reported, "mostly, I'm sorry to say, because of those books. All the Gillises in America wrote to me asking where they could buy them."

WILLIE GILLIS: THE FIGHTING GILLISES
Original oil painting for *Saturday Evening Post* cover, 13¼" x 10½"
September 16, 1944
Collection Mr. and Mrs. Ken Stuart
Photo courtesy Harry N. Abrams, Inc.

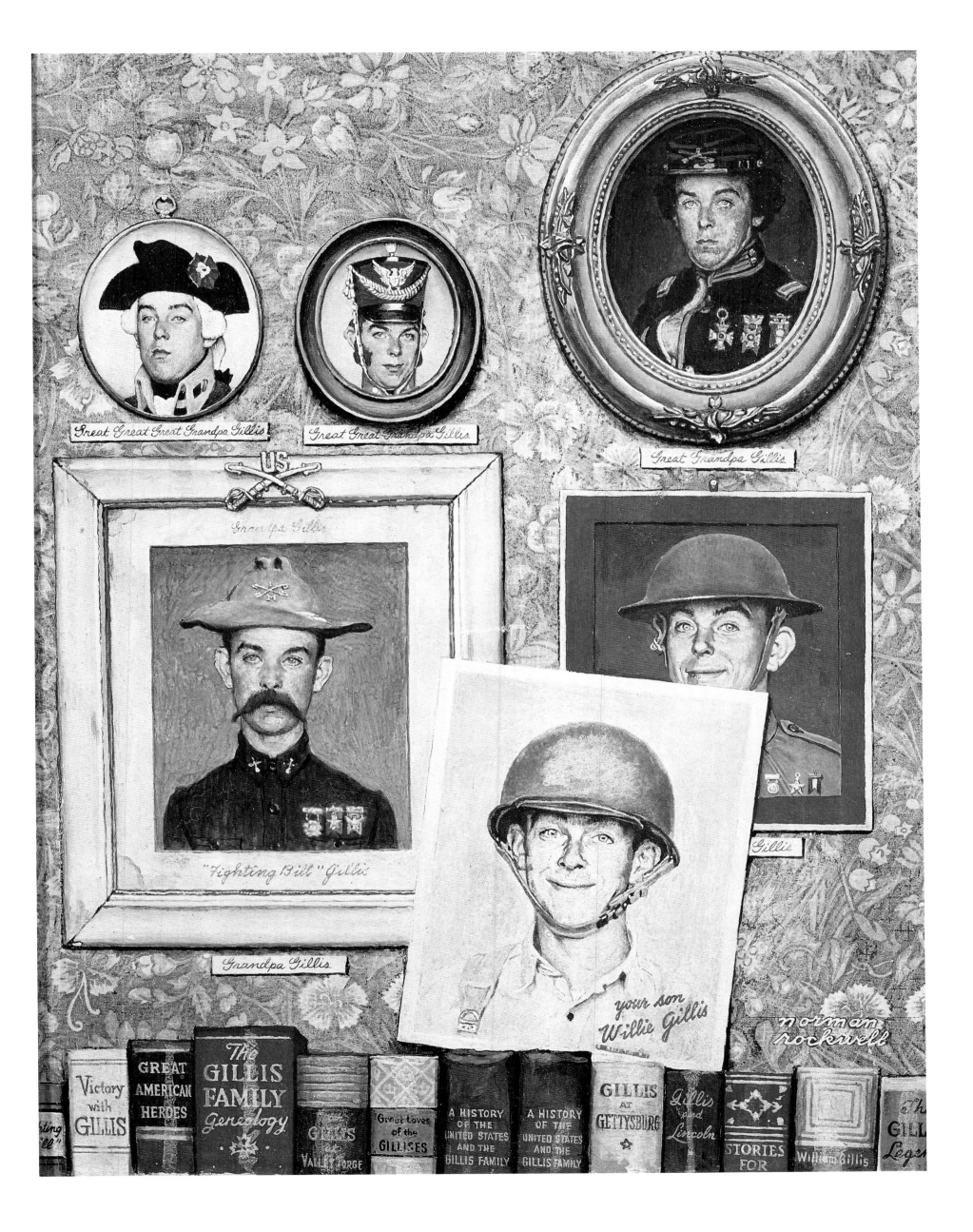

Great Great Great Grandpa Gillis

Great Great Grandpa Gillis

Great Grandpa Gillis

Grandpa Gillis

"Fighting Bill" Gillis

Gillis

your son
Willie Gillis

norman
rockwell

Victory with GILLIS

GREAT AMERICAN HEROES

The GILLIS FAMILY Genealogy

GILLIS at VALLEY FORGE

Great Loves of the GILLIES

A HISTORY OF THE UNITED STATES AND THE GILLIS FAMILY

A HISTORY OF THE UNITED STATES AND THE GILLIS FAMILY

GILLIS AT GETTYSBURG

Gillis and Lincoln

STORIES FOR

William Gillis

The GILLIS Legend

Oil on board, 11⅞" x 11"
Collection Alice De Boer, Martin Diamond,
Robert Buck
Photo courtesy American Illustrators Gallery/
Judy Goffman Fine Art

Rockwell was able to bring back the popular Willie Gillis when Bob Buck returned to Vermont from the Pacific after the war had ended. For the final cover in the Gillis series, Rockwell sent his subject to college. After weeding out a whole host of props, Rockwell eventually settled for only a few—the helmet, insignia, discharge document, books, and golf clubs—to describe where Willie had been and where he was going. For an authentic view from the dormitory window, Rockwell traveled to nearby Middlebury College to photograph the collegiate bell tower, which he referred to when he painted the cover later in his studio. Willie had come a long way from the innocent boy of the first draft call in 1941.

WILLIE GILLIS IN COLLEGE
Saturday Evening Post cover
October 5, 1946
Photo courtesy Curtis Publishing Co.

THE SATURDAY EVENING

POST

OCTOBER 5, 1946 10¢

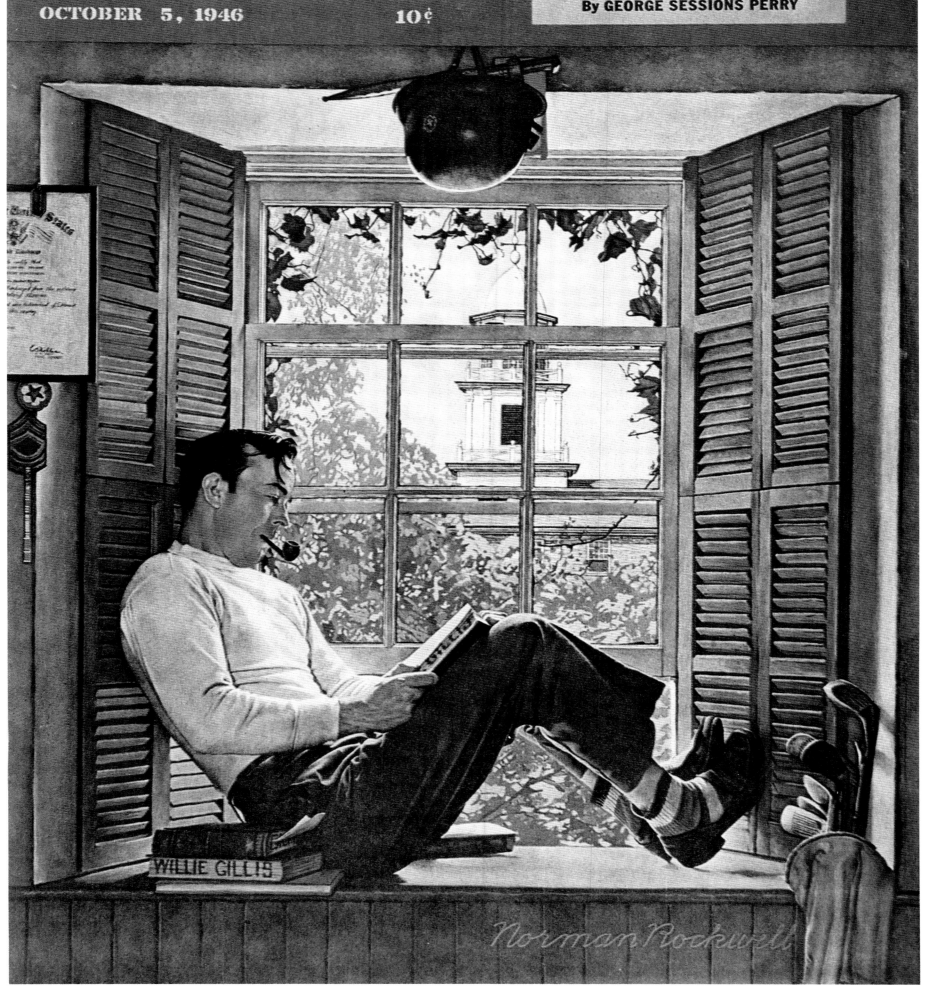

WILLIE GILLIS

Norman Rockwell

Support from the Homefront

Before America's entry into the war late in 1941, the government was already preparing itself with a draft call and the sale of National Defense bonds. Although this cover was published almost two weeks after Pearl Harbor, it was actually painted three or four months earlier, when the war still seemed distant and Christmas still represented a holiday of peace and goodwill.

To create this cover, Rockwell deviated somewhat from his normal procedure of photographing a real setting. He hired a model maker to create a small-scale replica of a newsstand located in midtown Manhattan. From this model Rockwell was able to experiment with lighting effects—a blue light on the outside to achieve the "cold" effect and a warmer illumination for the interior. The snow was actually fabricated with sugar, giving Rockwell the annoying task of swatting away flies while he worked during the autumn.

NEWS KIOSK IN THE SNOW
Saturday Evening Post cover
December 20, 1941
Photo courtesy The Norman Rockwell Museum at Stockbridge

THE SATURDAY EVENING POST

Dec. 20, '41
VOLUME 214. NUMBER 25

5 cts.
7c. IN CANADA

BUY DEFENSE BONDS

Merry Christmas

TIMES NEWS

Norman Rockwell

THE YORKSHIREMAN FLIES AGAIN
By ERIC KNIGHT

Several illustrators in the 1940s contributed to the war effort by producing numerous images of combat, yet their work has been long forgotten by most Americans. It is remarkable that Rockwell's images created during the war remain enduring reminders of the period, considering that this is the only picture of combat he produced. The powerful poster demonstrates that Rockwell's preference for nonmilitary subjects was clearly a matter of choice, not ability. In fact, it seems hard to believe that the artist who created this dramatic image of a machine gunner discharging his weapon from a cartridge that is nearly empty is the same artist who gave us the innocent young recruit called Willie Gillis. No other comparison so effectively testifies to Rockwell's enormous talent for evoking a scene that is convincingly real.

For this poster, Colonel Fairfax Ayers, a retired Army officer and Arlington neighbor, arranged to have a gun crew and machine gun sent to Rockwell's studio. Rockwell was amused that the gunner let Rockwell rip his shirt into tatters for the picture, but insisted on having his gun in shining order.

LET'S GIVE HIM ENOUGH AND ON TIME
Original oil painting for U.S. Army poster, 42" x 50"
1942
Collection U.S. Army Center of Military Art
Photo courtesy United Services Automobile Association

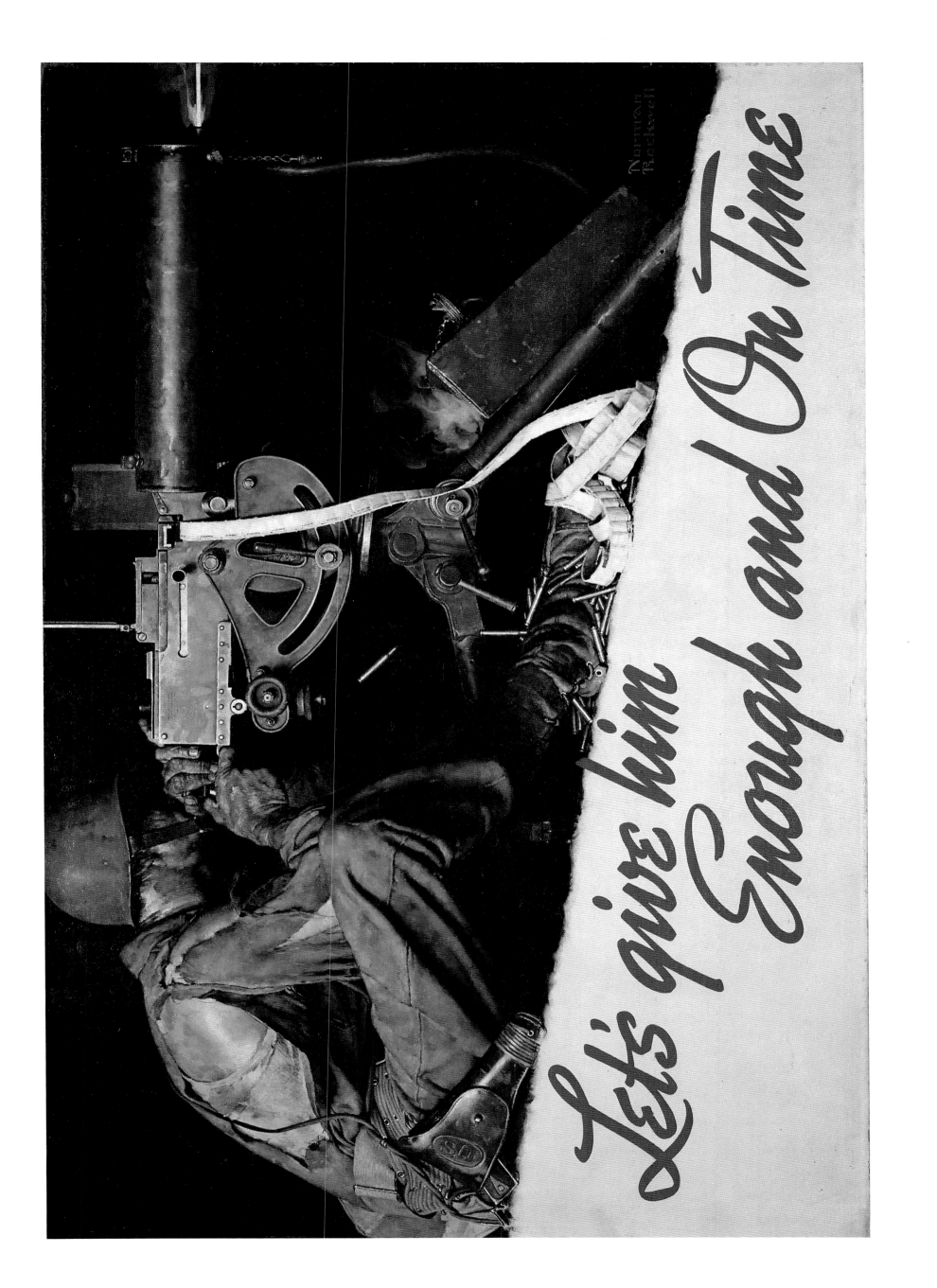

Norman Rockwell

Let's give him Enough and On Time

From one year to the next, virtually without interruption, Rockwell created an illustration for every Boy Scout calendar published between 1926 and 1978. In 1944 it was appropriate to use the calendar as a statement of the Boy Scouts' commitment to the American cause. The Scouts were supporting the war effort by collecting aluminum and rubber, acting as dispatch bearers and fire watchers for Civil Defense, distributing air-raid and war-bond posters and pamphlets, and raising food in victory gardens. To express the Boy Scouts' dedication, Rockwell painted the figure of a First-Class Scout, posed before the American flag with his hand raised in the three-finger Scout salute.

Rockwell completed this painting later than usual because he had fallen behind schedule that year, having spent so much time on the "Four Freedoms." Exhausted but relieved, he sent off the painting for the Boy Scout calendar and took it easy for the rest of the day. That night his studio burned to the ground, destroying many cherished items—paintings, sketches, costumes, antiques, photographic records. Rockwell immediately relocated his studio with a minimum disruption of his busy schedule, and friends helped make up for the loss by replacing what they could of the illustrator's collection of props and publications.

WE, TOO, HAVE A JOB TO DO
Original oil painting for Boy Scout calendar, 30" x 22"
1944
Reproduced from the archives of Brown & Bigelow and by permission of the Boy Scouts of America
Photo courtesy the Boy Scouts of America

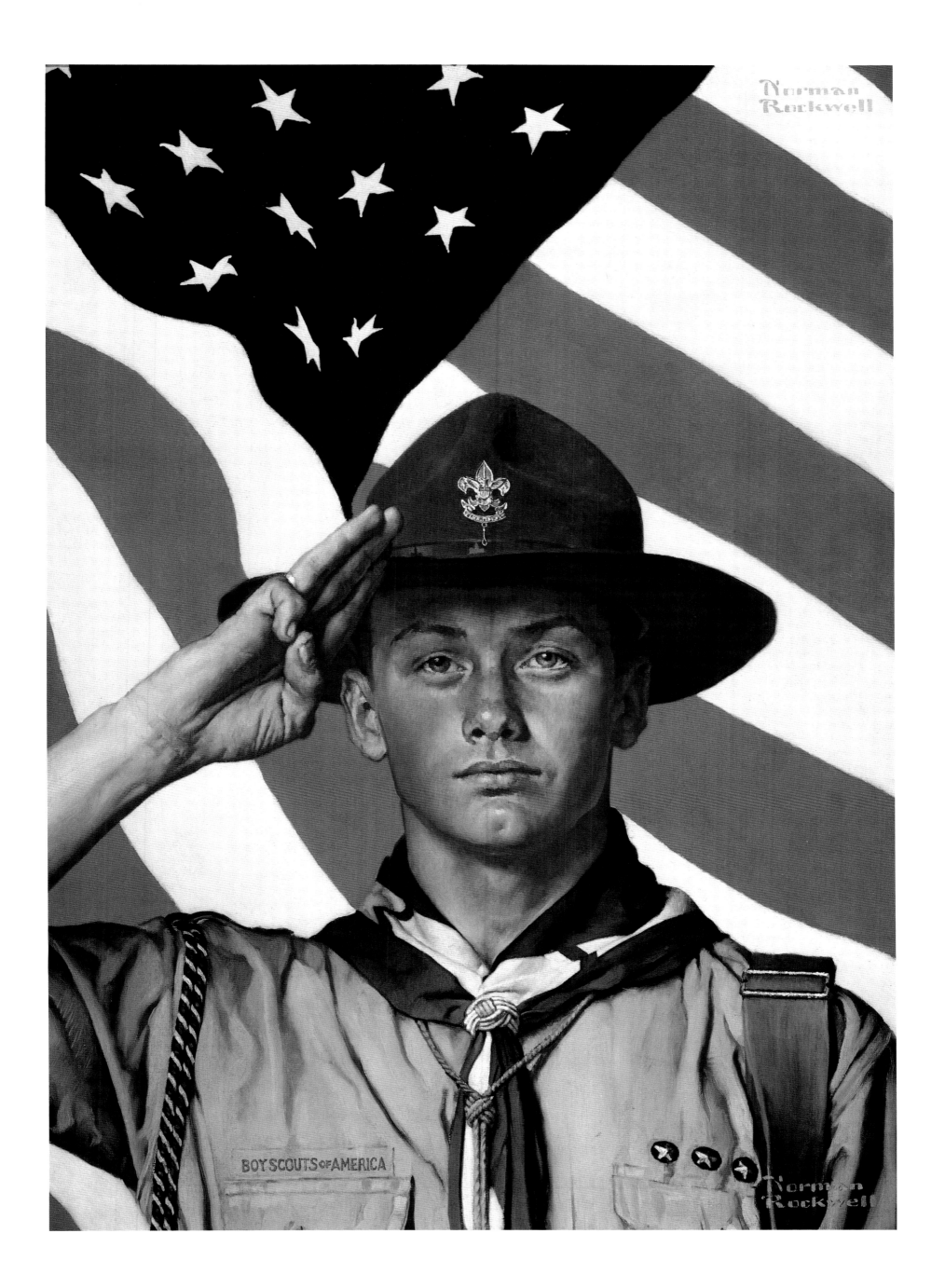

During World War I the United States Office of War Information had effectively initiated a large-scale promotional effort and asked illustrators to volunteer their talents, but it did not do this during World War II. This may explain why there are so many more examples of public service posters in the First than in the Second World War. It may also explain why Rockwell was not able to involve the government in publishing his "Four Freedoms," eventually turning to the *Saturday Evening Post* for their publication.

Like so many of his colleagues, Rockwell stood ready to volunteer his services for the war cause, as this poster urging Americans to mine their coal so aptly demonstrates. In his efforts to make the man's facial expression sincere, Rockwell asked an Arlington neighbor to pose as the coal miner. His model had good reason to assume a genuine expression of pride and apprehension. Like the coal miner pictured in the poster, with the two stars pinned to his coveralls, he had two sons in the service.

MINE AMERICA'S COAL
Original oil painting for U.S. Office of War Information poster,
21" x 14"
1943
Collection The Norman Rockwell Museum at Stockbridge
Photo courtesy The Norman Rockwell Museum at Stockbridge

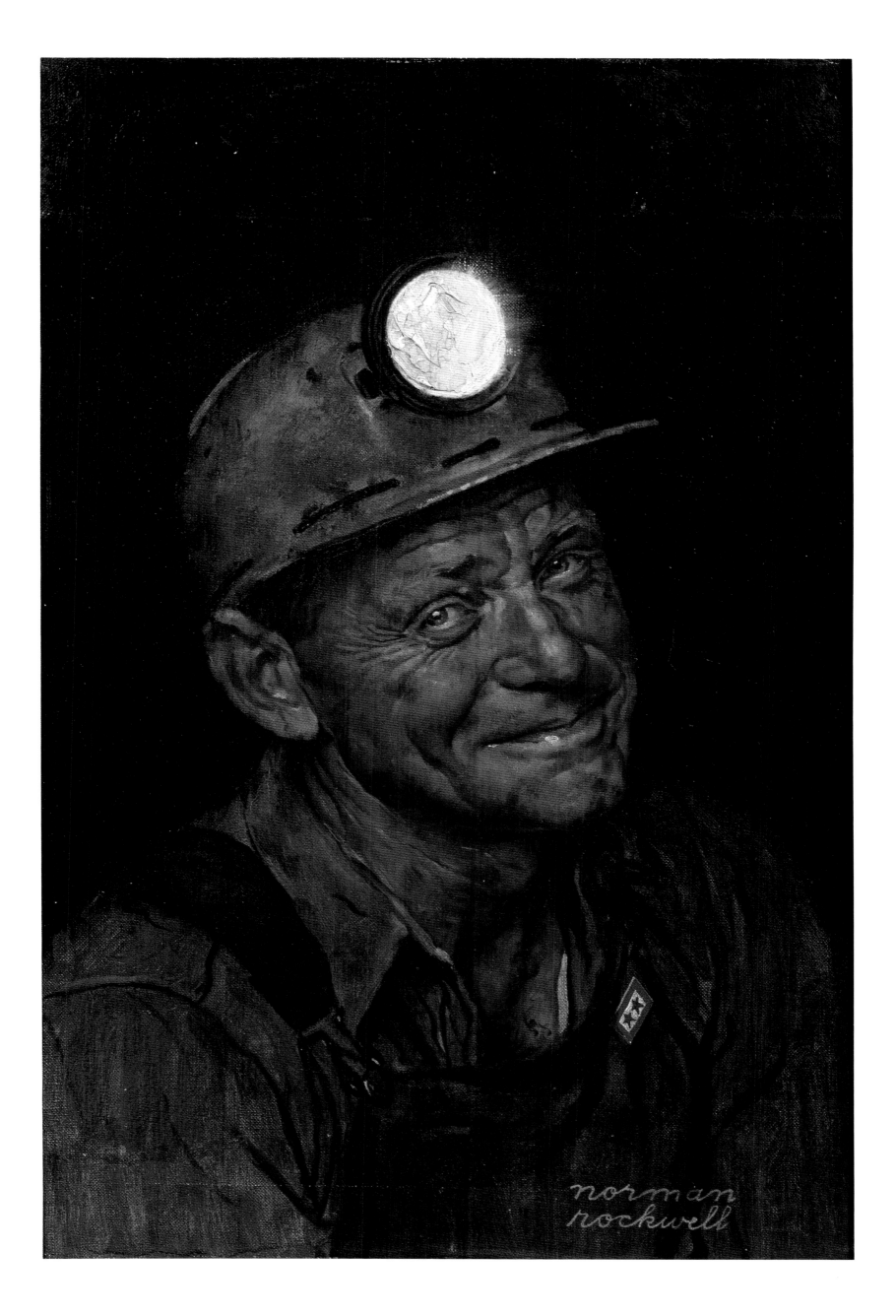

norman
rockwell

With so many men in the service and so much labor required to meet the military and domestic needs of the country, an unprecedented phenomenon occurred: millions of American women were now doing work of which only men had been thought capable. In the aviation industry alone, the proportion of women employees soared from one percent in 1941 to an astonishing sixty-five percent in 1943. And in most heavy industries, from which men had traditionally barred them, women discovered in the sudden urgency of wartime production what they had suspected all along—that there was nothing in their makeup that made them incapable of performing as well as their male counterparts.

With unequivocal enthusiasm, Rockwell produced two covers for the *Post* exalting this turn of events. Borrowing from the pose of the prophet Isaiah created by Michelangelo in the sixteenth century for the Sistine Chapel, Rockwell shows here the power and virtue of women who have filled in for the men. The American flag behind her, Rosie the Riveter places her foot squarely on top of *Mein Kampf*—a striking use of propaganda in a forceful celebration of women doing their part in the war effort.

ROSIE THE RIVETER
Original oil painting for *Saturday Evening Post* cover
May 29, 1943
Whereabouts of original unknown
Photo courtesy The Norman Rockwell Museum at Stockbridge

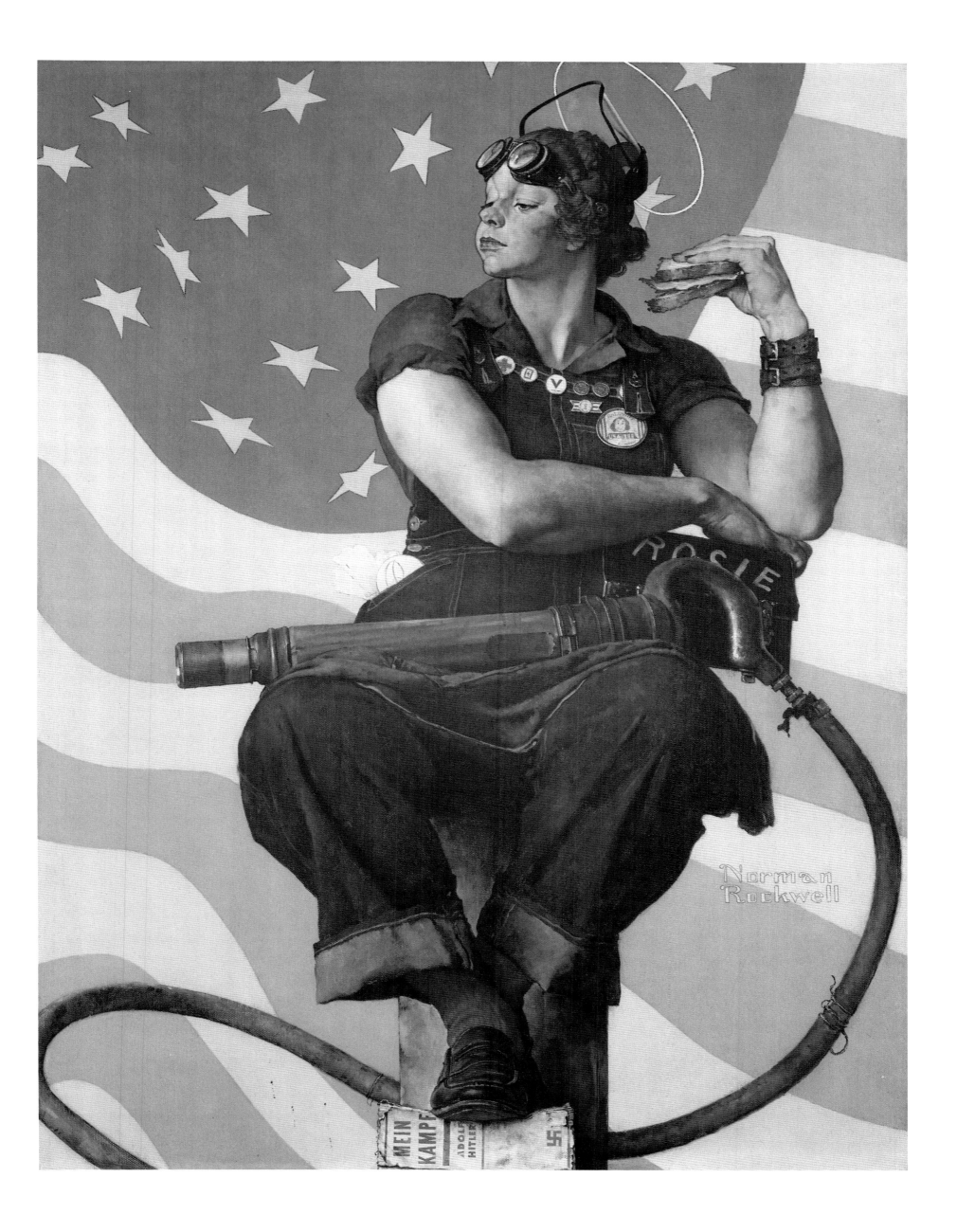

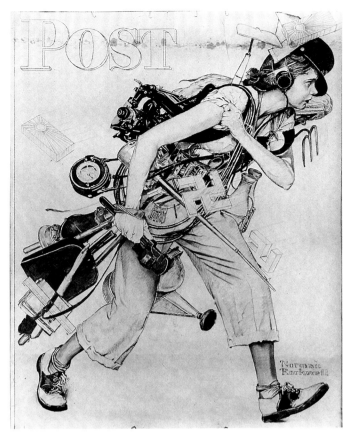

Charcoal on paper, 41" x 33"
Photo courtesy The Norman Rockwell Museum at Stockbridge

O nly three months after the appearance of Rosie the Riveter in the *Post*, Rockwell created another cover honoring women war workers for the Labor Day issue. Rockwell took no chances of omitting the areas in which women were making their contributions, and he overloaded his model with a multitude of props. "Getting the props all together and arranging them on the model presented quite a problem," he noted. The *Post* listed thirty-one wartime occupations suggested by these props and invited readers to notify the editors if any others were detected. The *Post's* list included boardinghouse manager and housekeeper (keys on right hip); chambermaid, cleaner, and household worker (mop, dust pan and brush); service superintendent (time clock); switchboard and telephone operator (earphone and mouthpiece); grocery-store woman and milk-truck driver (milk bottles); electrician for repair and maintenance of household appliances and furnishings (electric cable); plumber and garage mechanic (monkey wrench, small wrenches); seamstress (large scissors); typewriter-repair woman, stenographer, typist, editor, and reporter (typewriter); baggage clerk (baggage checks); bus driver (punch); conductor on railroad, trolley, or bus (conductor's cap); filling-station attendant and taxi driver (change holder); oiler on railroad (oil can); section hand (red lantern); bookkeeper (pencil over ear); farm worker (hoe and potato fork); truck farmer (watering can); teacher (schoolbooks and ruler); public health, hospital, or industrial nurse (Nurses' Aide cap).

LIBERTY GIRL
Saturday Evening Post cover
September 4, 1943
Photo courtesy The Norman Rockwell Museum at Stockbridge

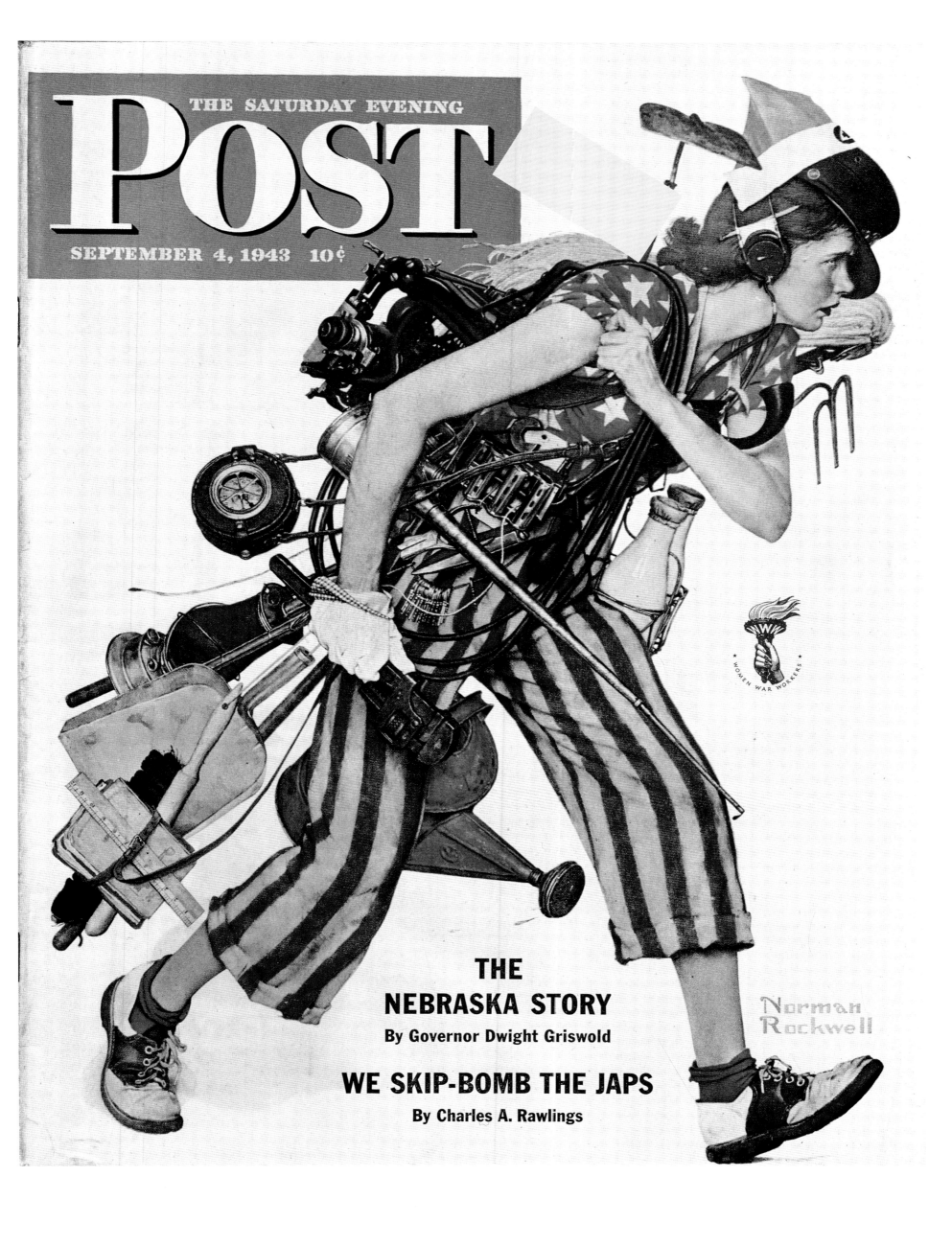

War News

The *Saturday Evening Post* reached millions of subscribers each week, many living in areas as remote from the war as Rockwell's own Arlington, Vermont. While a large portion of Rockwell's *Post* covers were designed to provide some diversion from the terrible events taking place in the Pacific and in Europe, the war was never far from everyone's thoughts, regardless of how remote they were from the action. The Christmas cover Rockwell created just twelve months earlier, in 1941, hinted only faintly at the incipient crisis. By the time Christmas arrived in 1942, it promised to be a very different holiday since the war had intensified.

MERRY CHRISTMAS
Saturday Evening Post cover
December 26, 1942
Photo courtesy The Norman Rockwell Museum at Stockbridge

THE SATURDAY EVENING
POST

December 26, 1942 10¢

Norman
Rockwell

"Merry Christmas"

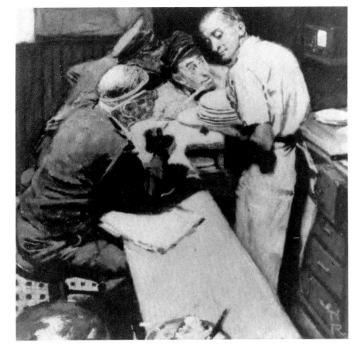

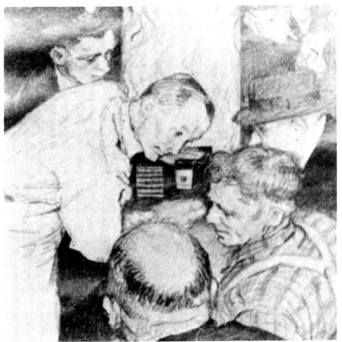

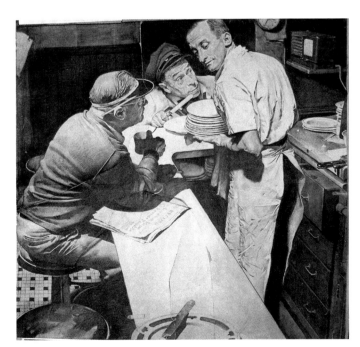

For months Americans had been in a state of suspension about the events at the battlefronts as the Allies were penetrating the Continent and the American forces were breaching the Japanese defenses on the Pacific. So tense was early spring 1944 that Rockwell decided to depict first three, then four, men seated in anxious expectation of war news on the radio. But in the end Rockwell probably felt that it was not absolutely clear what the men were doing all hunched over a lunchroom counter, and he discarded the idea in favor of the cover shown on page 51, in which the action is unmistakable. Rockwell was a perfectionist, and he could abandon an illustration, even near completion, in favor of another idea.

Although this painting was not ultimately used as a *Post* cover, it has nevertheless become almost as familiar as the one that was published on the issue of April 29, 1944. The superb quality of the painting attests to Rockwell's gift as an artist and to his unrelenting quest for perfection in his work.

WAR NEWS
Unused oil painting for *Saturday Evening Post* cover, 35" x 33"
1944
Collection The Norman Rockwell Museum at Stockbridge
Photo courtesy The Norman Rockwell Museum at Stockbridge

Top: Oil on board, 12" x 12"
Center: Charcoal on paper, 39" x 38"
Bottom: Pencil on paper
Photos courtesy The Norman Rockwell Museum at Stockbridge

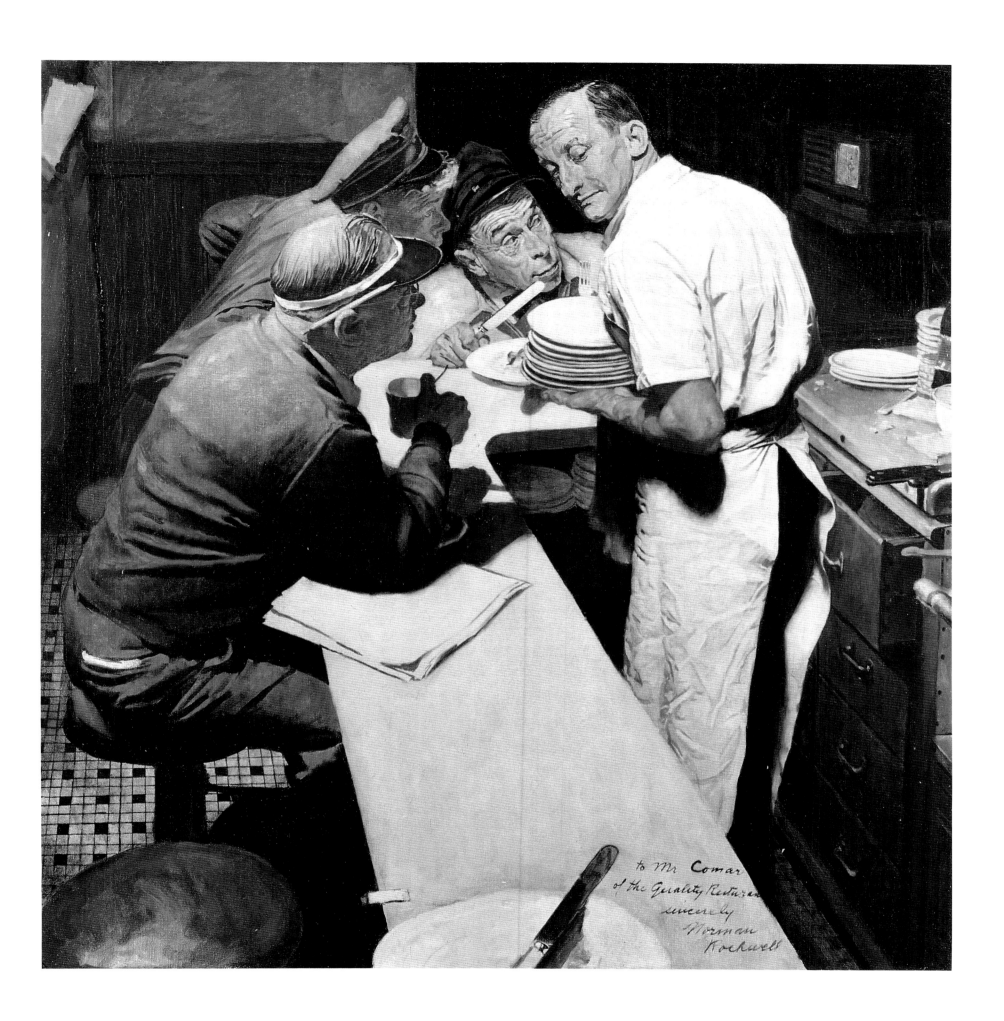

to Mr. Comar
of the Quality Restaurant
sincerely
Norman
Rockwell

After wrestling at great length with an idea for this scene, Rockwell abandoned his early efforts (shown on the preceding spread) and started over. When he was unsure about a subject, Rockwell frequently sought the advice of friends. "He'd ask you what you didn't like about his painting in progress," a friend from Arlington recalled, "and he'd watch your face while you studied it. If you didn't get the story *right away* he knew something was wrong." The cover finally appeared in April, six weeks before D Day, the beginning of the end of the war.

CHARTING WAR MANEUVERS
Saturday Evening Post cover
April 29, 1944
Photo courtesy The Norman Rockwell Museum at Stockbridge

THE SATURDAY EVENING
POST
APRIL 29, 1944 10¢

A HILARIOUS NEW SERIAL
By PH...

SLICKEST TRICK...
By LT. (j.g.) WILLIAM BRA...

Norman Rockwell

ARMCHAIR GENERAL

Taking Care
of Business

While war raged in Europe and in the Pacific, daily life continued at home, but not without dramatic changes. When food rationing was instituted as a measure designed to conserve the purchase of food items, the ration board became a fixture of the American scene. Each day parades of citizens marched through the ration board office to request special privileges from a board of volunteers.

To gather subject matter for his painting, Rockwell went to the nearest ration board, in Manchester, Vermont, where he photographed the members of the board and the variety of people lining up for the hearings. In the painting Rockwell is seated on the left, characteristically smoking his pipe. It was like Rockwell to place himself among his models. Although he had become a national celebrity, Rockwell did not regard himself as any different from any ordinary American citizen. His understanding of his community originated from his feeling of kinship with his neighbors.

NORMAN ROCKWELL VISITS A RATION BOARD
Story illustration for the *Saturday Evening Post*
July 15, 1944
Photo courtesy The Norman Rockwell Museum at Stockbridge

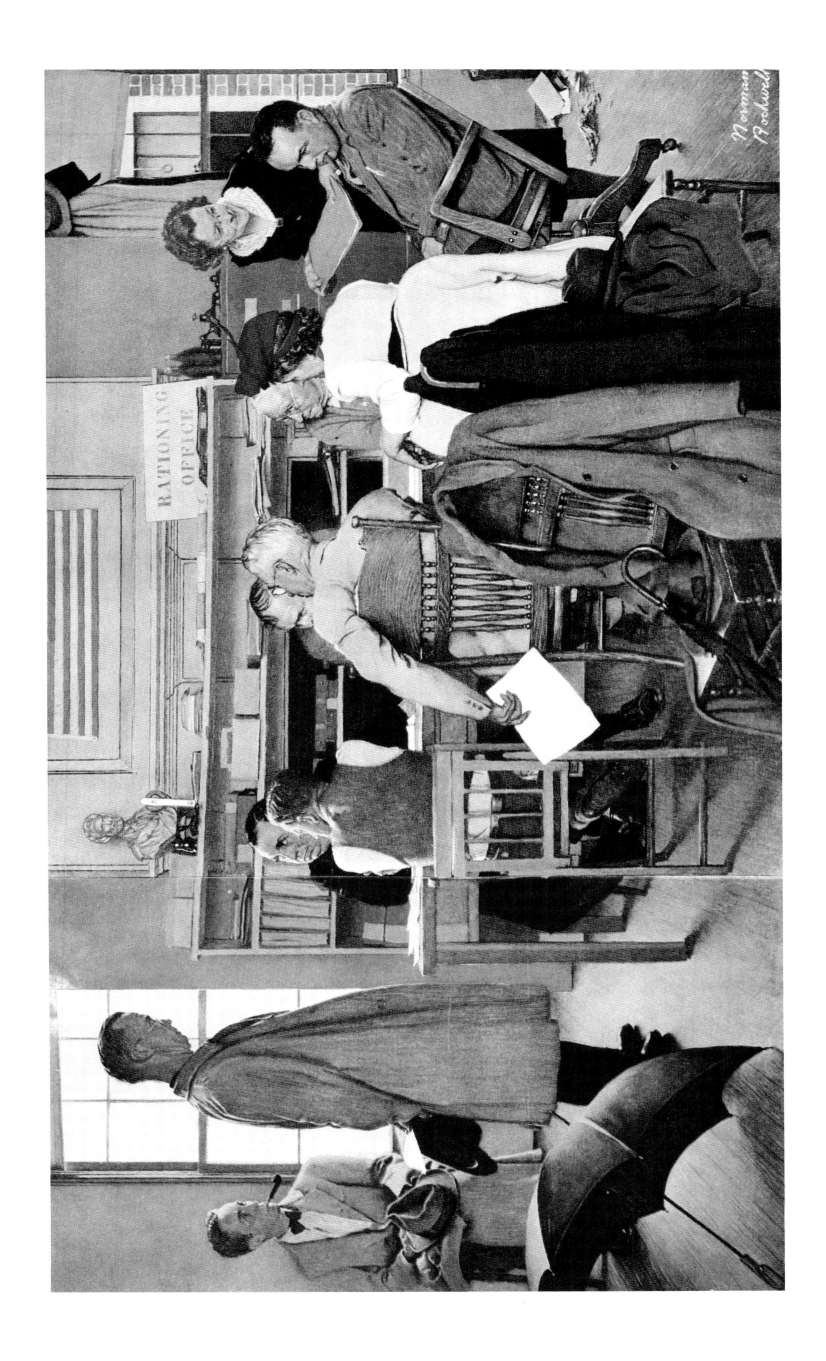

Although Rockwell himself tended to be apolitical, he had great respect for the electoral process, regarding it as the cornerstone of democracy. While American forces were staking their lives in a war against tyranny, Rockwell remained firm in his support of the democratic system, and he celebrated the fact that citizens had a right to choose their leaders.

For the 1944 Election Day issue of the *Post*, Rockwell did this cover and a special feature inside, portraying the activity at the polls. "In search for a truly representative background," the *Post* editors reported, "Rockwell went straight to the heart of America, specifically to Cedar Rapids, Iowa." In the process of creating the magazine feature, Rockwell invented a character whom he dubbed Junius P. Wimple, a citizen representing the majority of the voting public. Being in the majority, of course, meant that Wimple's candidate always wins. In this case, the majority elected Franklin Delano Roosevelt to a fourth term as president of the United States.

WHICH ONE?
Saturday Evening Post cover
November 4, 1944
Photo courtesy The Norman Rockwell Museum at Stockbridge

Oil on board, 10½" x 10"
Private collection
Photo courtesy The Norman Rockwell Museum
at Stockbridge

As the war was drawing to a close, Rockwell's covers for the *Post* started to reflect the relaxation of tensions at home. Life was beginning to resume its normal course, including the unpleasant routine of filing tax returns. (In 1945 income taxes were still due on March 15, rather than April 15, which explains the date of the cover.) There is a sense here that even taxes could be taken in stride now that the worst of the horrors seemed behind, and the cat, named Morgenthau, could doze peacefully while life moved on.

INCOME TAX

Saturday Evening Post cover
March 17, 1945
Photo courtesy The Norman Rockwell Museum at Stockbridge

THE SATURDAY EVENING

POST

MARCH 17, 1945 10¢

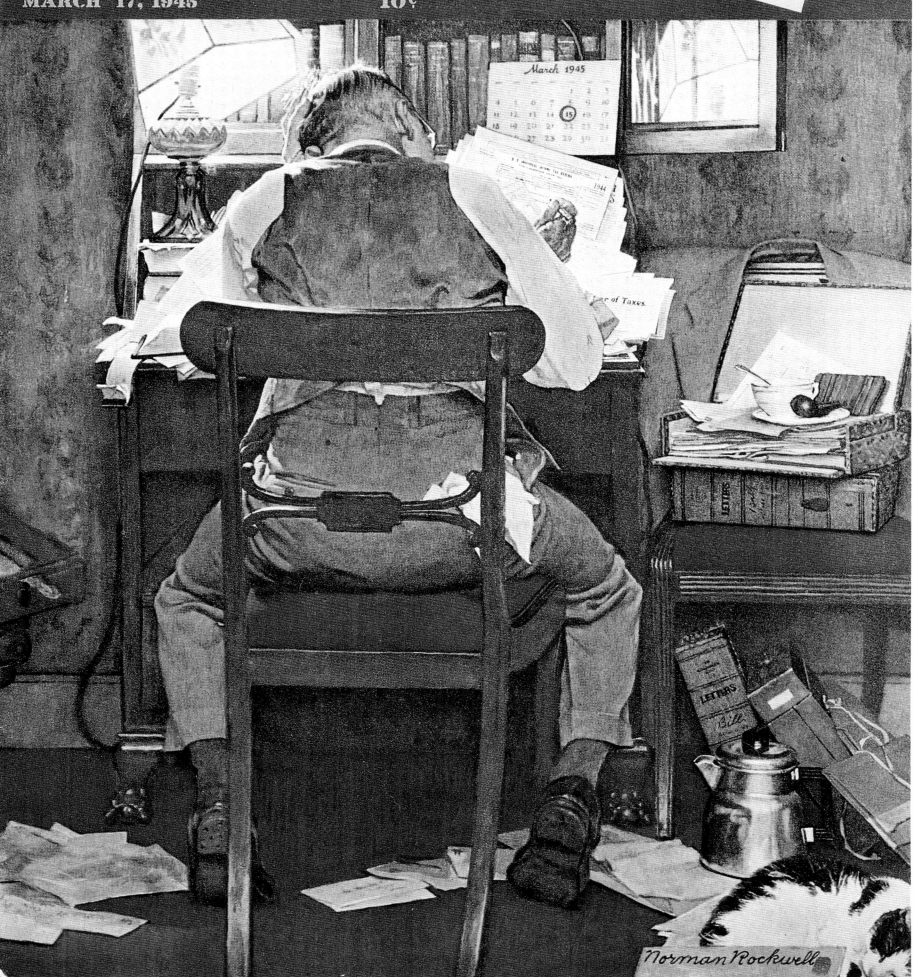

Norman Rockwell

The Laughter That Heals

As Americans grew increasingly tense about the developments abroad, they looked to Norman Rockwell for diversion. His entertaining portrayal of military life provided an antidote to the unfortunate reality. Americans could identify with a young and innocent Rockwell soldier, like Private Gallagher here, working hard to come up to standard, while trying to disguise his feelings of inadequacy at the same time.

Rockwell liked to say that he wanted his pictures to make people laugh and sigh at the same time. This approach to illustration was an extension of his outlook on life. "Maybe as I grew up and found that the world wasn't the perfectly pleasant place I had thought it to be, I unconsciously decided that, even if it wasn't an ideal world, it should be so and so I painted only the ideal aspects of it. . . . If there was sadness in this created world of mine, it was a pleasant sadness. If there were problems, they were humorous problems." With humor Rockwell provided distraction from the realities of the war; through laughter he helped heal the wounds that the war inflicted.

THE GODDESS AND PRIVATE GALLAGHER
Story illustration for the *Saturday Evening Post*
October 11, 1941
Photo courtesy Curtis Publishing Co.

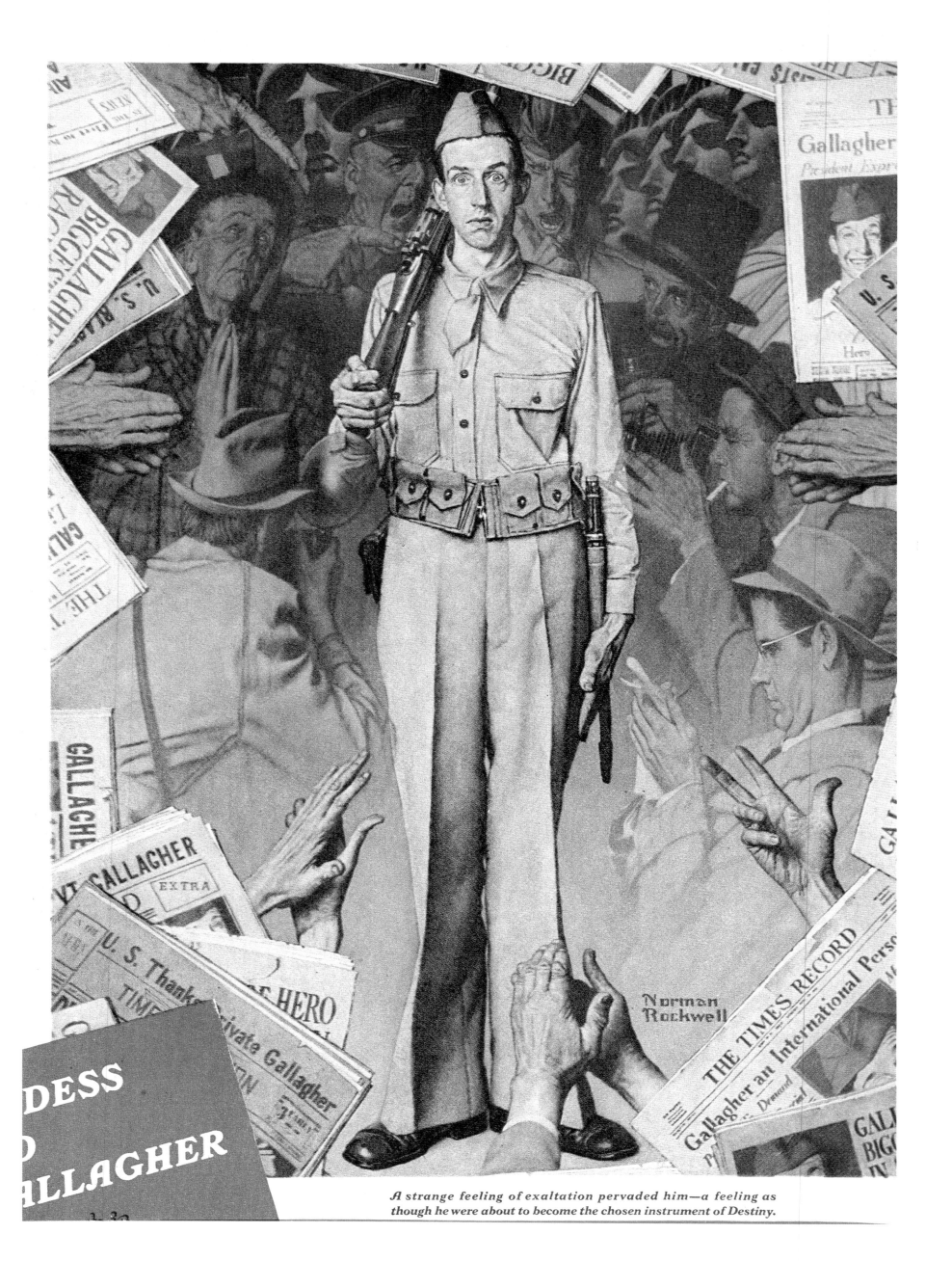

A strange feeling of exaltation pervaded him—a feeling as though he were about to become the chosen instrument of Destiny.

Oil on canvas board, 13¼" x 10½"
Collection Center Art Galleries
Photo courtesy The Norman Rockwell Museum
at Stockbridge

The subject of Thanksgiving always furnished Rockwell with many ideas. Later in the war, the holiday would generally suggest the family—the joys of being together as a family, or the longing for an absent member of the family. But during the first year of the war Rockwell's *Post* covers tended to focus on the humorous, giving an increasingly apprehensive American public something to smile about. Here an Army chef slumps in exhaustion after having prepared an enormous Thanksgiving meal for the 137 men stationed at Fort Ethan Allen in Vermont. Anticipating objections by skeptics regarding the lavish menu, Rockwell actually gathered a list of Thanksgiving fare being planned for all the soldiers in the New England area as evidence that he had not exaggerated.

CHEF WITH THANKSGIVING MENU
Saturday Evening Post cover
November 28, 1942
Photo courtesy The Norman Rockwell Museum at Stockbridge

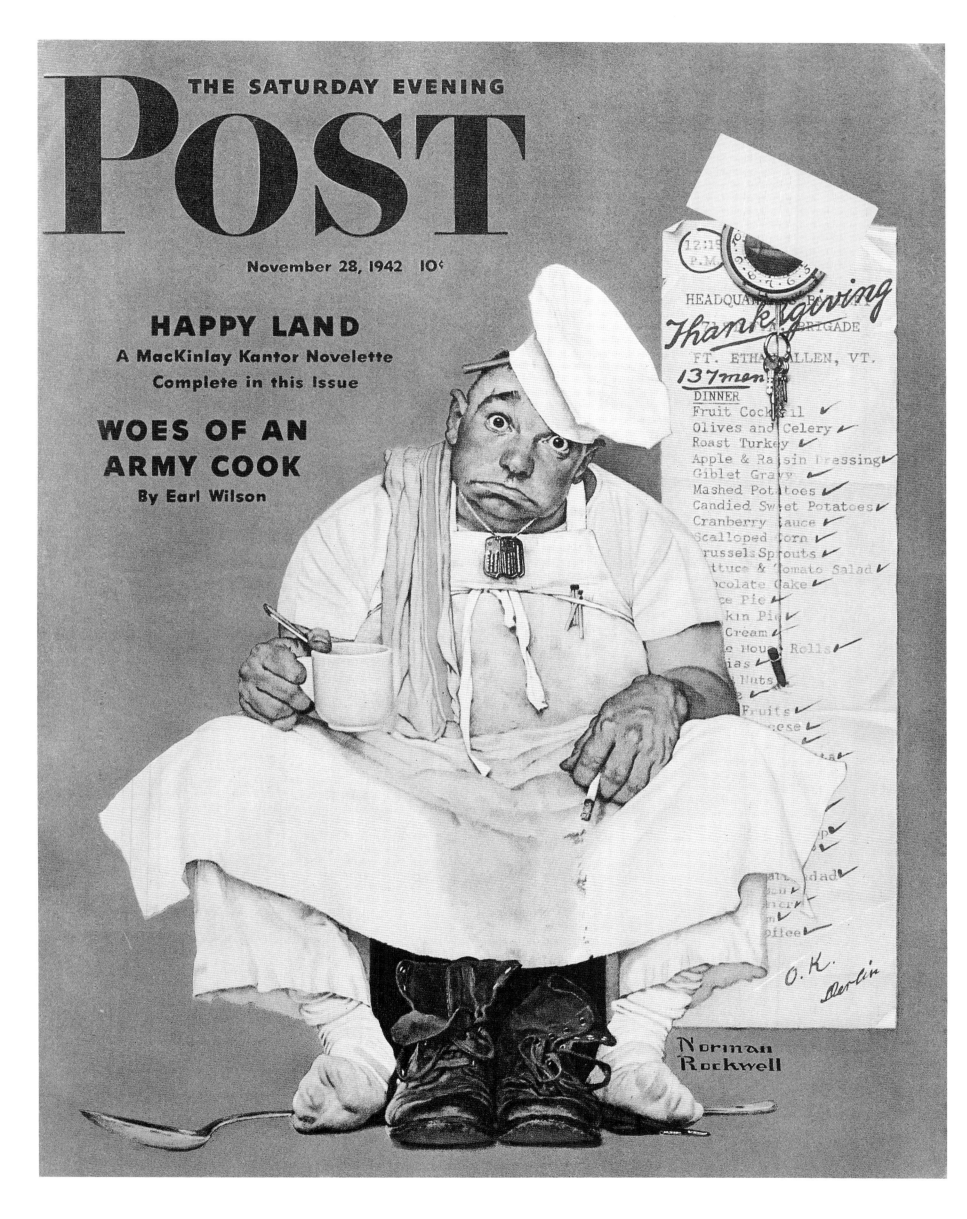

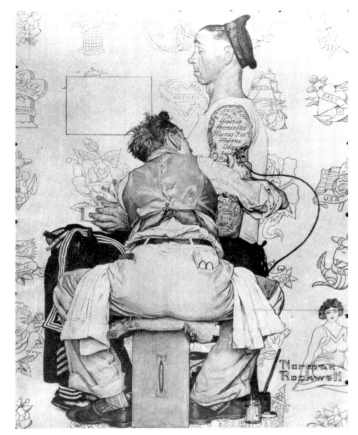

Pencil and charcoal on paper, 40" x 30"
Photo courtesy The Norman Rockwell Museum
at Stockbridge

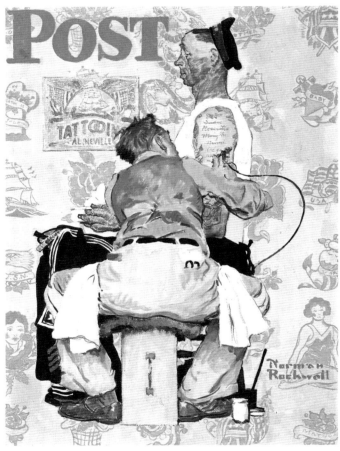

Oil on board, 27⅛" x 21¾"
Photo courtesy American Illustrators
Gallery/Judy Goffman Fine Art

Sheer fantasy enabled Rockwell to create this tattooed environment in which the two men seem to float. Yet fantasy alone never dominated a Rockwell picture. Each detail was carefully scrutinized for accuracy. The illustrator consulted with former sailors and with a tattooist he managed to locate on the Bowery in New York, and from whom he acquired the authentic equipment required for the picture. Rockwell never failed to identify the precise service and rank of military personnel in his pictures, details that are especially important to the public in wartime. Rockwell's good friend Mead Schaeffer was happy to pose as the tattooist, although he insisted that Rockwell had exaggerated the size of his rump in the final painting.

TATTOO ARTIST
Saturday Evening Post cover
March 4, 1944
Photo courtesy The Norman Rockwell Museum at Stockbridge

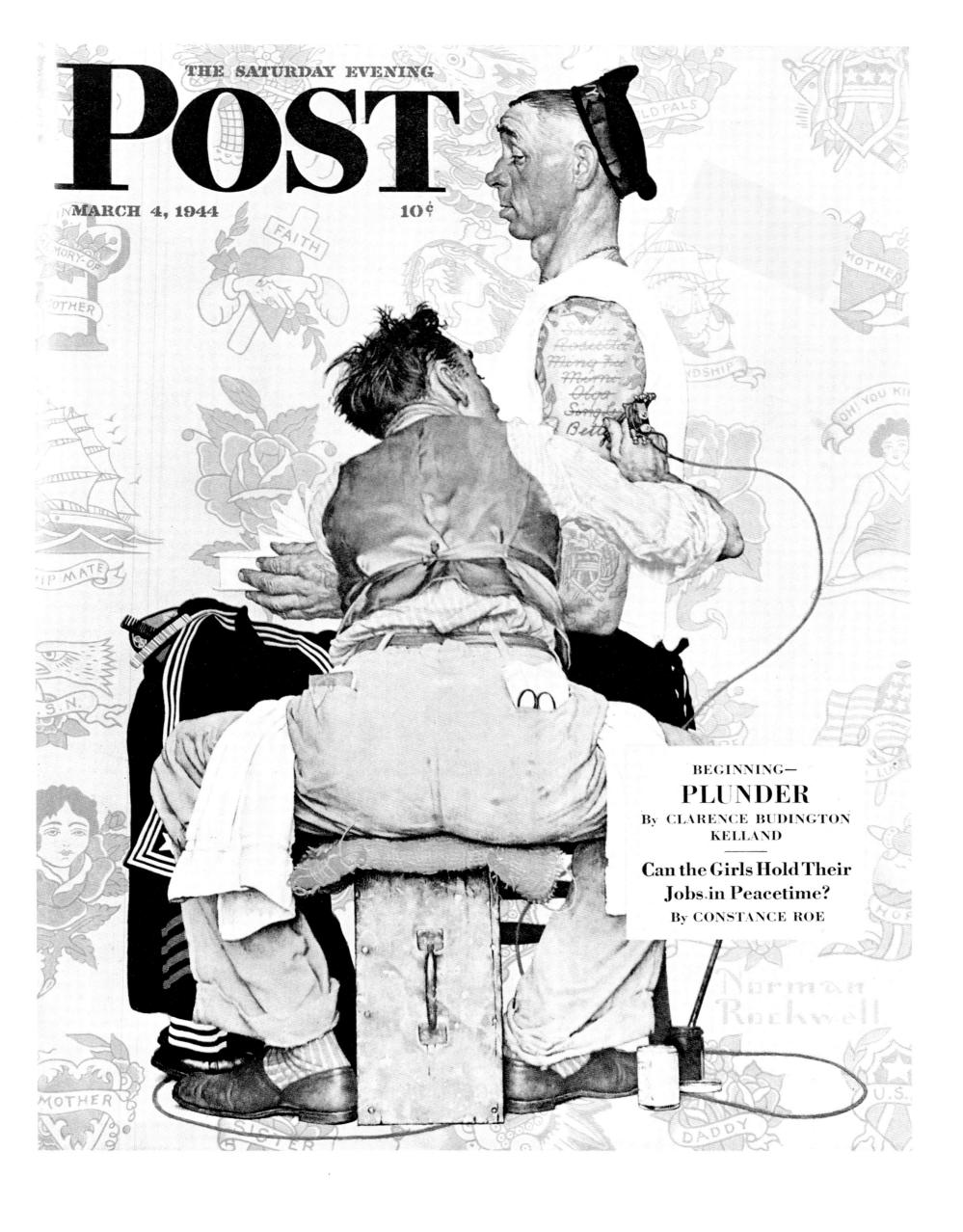

THE SATURDAY EVENING

POST

MARCH 4, 1944 10¢

BEGINNING—
PLUNDER
By CLARENCE BUDINGTON
KELLAND

Can the Girls Hold Their
Jobs in Peacetime?
By CONSTANCE ROE

Far from Home

By 1943 the real impact of the war had hit home. As news from the warfront conveyed harrowing accounts of victories and defeats, the future seemed uncertain, making separation from loved ones even more painful. Thanksgiving that year was a day on which to count your blessings. One of Rockwell's most poignant Thanksgiving covers—of a European girl giving thanks for a meager meal provided by an American soldier—suggested that there was much to be thankful for. Wrapped in the soldier's tattered overcoat, her feet warmed by rags, she sits among the ruins of a building destroyed in battle, feeling grateful to be alive.

THANKSGIVING: GIRL PRAYING
Saturday Evening Post cover
November 27, 1943
Photo courtesy The Norman Rockwell Museum at Stockbridge

THE SATURDAY EVENING

POST

NOVEMBER 27, 1943　　10¢

**BILLION-DOLLAR
PLANE BUILDER**
By ALVA JOHNSTON

A Gay Short Story
By ROBERT CARSON

Norman Rockwell

THANKSGIVING

At the heart of Rockwell's work lies his profound faith in the goodness of humanity. Incapable of violence himself, Rockwell was in full support of the ideals for which World War II was fought. The heroes in his pictures are not on the battlefield; they are ordinary citizens who are putting into everyday practice the beliefs of a free society. Even far from home, Rockwell's soldier shares the values that are nourished in a world free of tyranny. Every American who has fought on a battlefield populated by civilians has witnessed the suffering of families who have fallen victim to forces beyond their control. Without having been in combat himself, Rockwell understood that these private moments were likely to be remembered long after the battle was over.

THE AMERICAN WAY
Original oil painting for Disabled American Veterans poster, 29" x 23"
1944
Collection Disabled American Veterans
Photo courtesy The Norman Rockwell Museum at Stockbridge

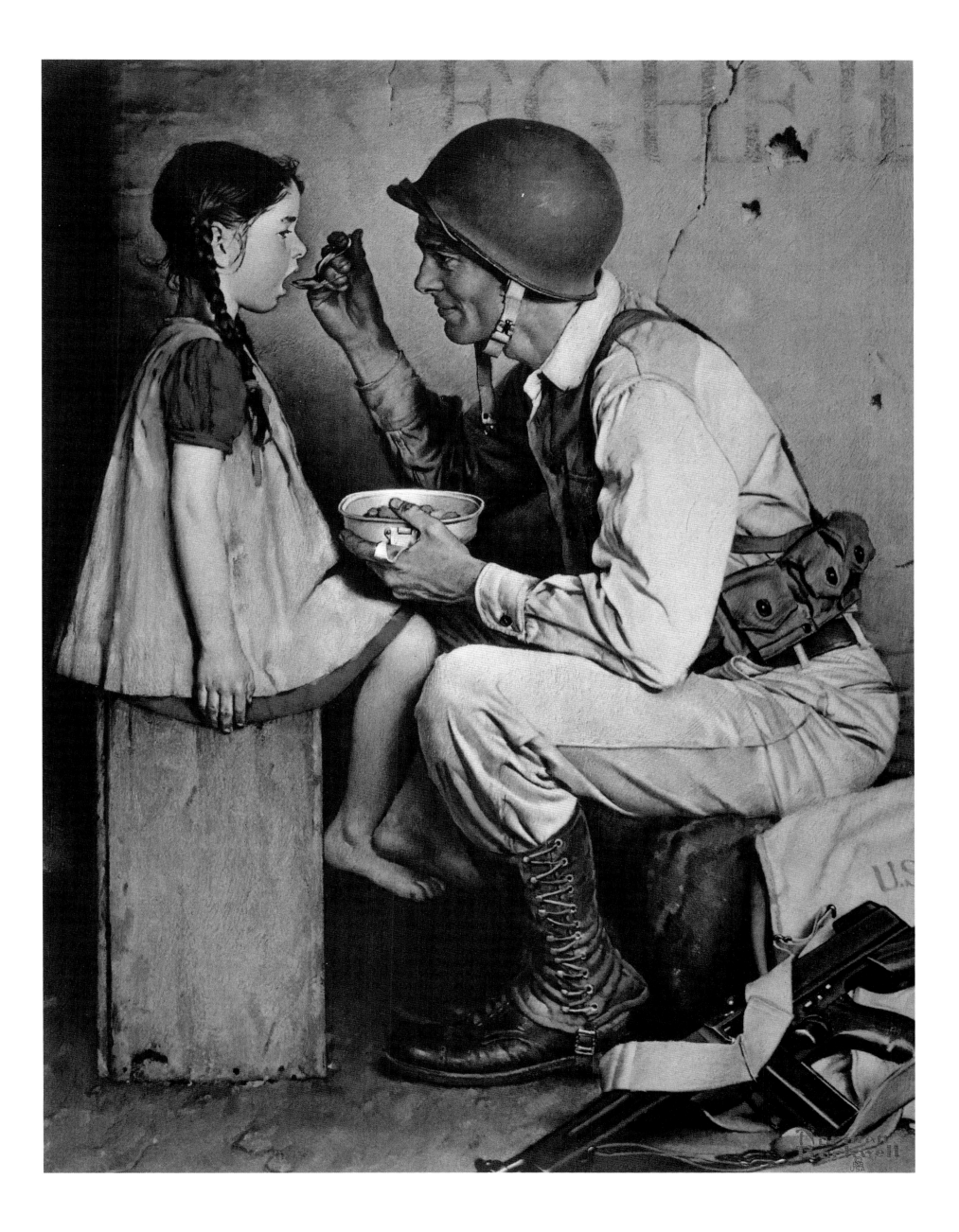

After nearly three years of war it seemed hard to remember what life had been like before. The whirlwind had propelled men into combat, transforming their reality so completely that being out of action was unthinkable. Rockwell honored the dedication of the American servicemen by portraying the sadness of a disabled soldier who has left his friends on the battle-field to carry on the war he has fought so valiantly. The decorated private, for whom Rockwell's neighbor Roy Cole posed, is determined to support the war effort in the only way he is now able, by purchasing U.S. Defense Savings Bonds.

DISABLED VETERAN
Original oil painting for *Saturday Evening Post* cover, 43" x 34"
July 1, 1944
Collection American Illustrators Gallery/Judy Goffman Fine Art
Photo courtesy The Norman Rockwell Museum at Stockbridge

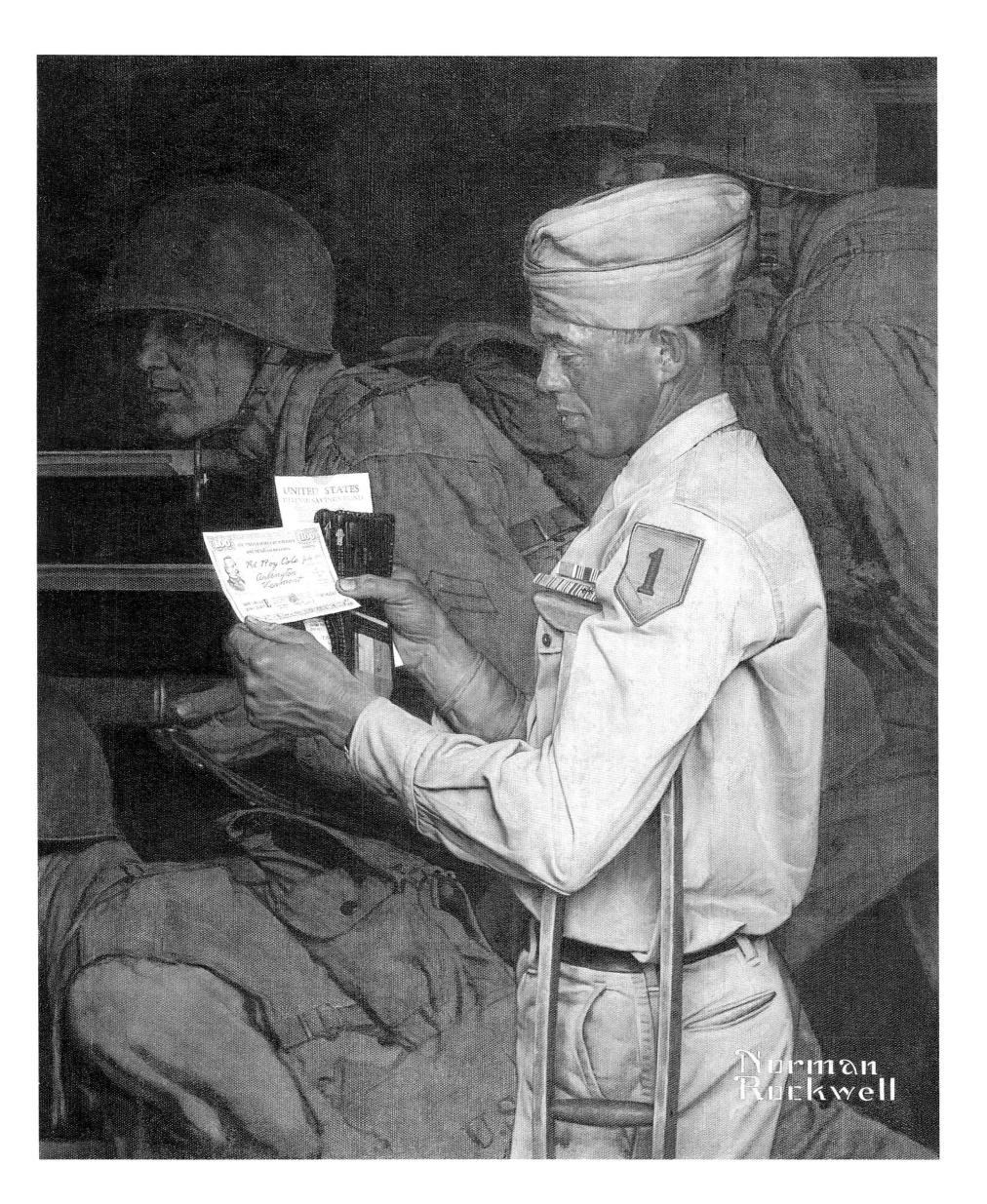

Homecoming

No theme held more richness for Rockwell than coming home. And as the war was reaching its final turning point, Rockwell found endless opportunities for playing on this joyous theme. Christmas, of course, was an added bonus. "I got the notion that I would like to do a railroad station interior during a wartime Christmas season—the pathos and humor; the mother meeting the son; the wife meeting her husband; one lover meeting another," Rockwell commented.

On his way to California in June, Rockwell stopped off at Chicago and taxied around to several stations before selecting the North Western Railroad Station. The station master hauled out a huge ladder and platform (used for washing the glass ceiling), which Rockwell and his photographer mounted for better viewing. "There were many astonished travelers that day, because everyone that came in was made to go through a single gateway so we could take pictures. We photographed over a hundred soldiers, sailors, and marines meeting their families and friends. We even staged a few meetings. I arranged for one red-head to kiss a Navy Lieutenant—she said it was too bad I wasn't taking time exposures. (They proved to be a married couple!)" The man waving a piece of paper in the upper right is Rockwell himself.

NORTH WESTERN RAILROAD STATION AT CHRISTMAS
Saturday Evening Post cover
December 23, 1944
Photo courtesy The Norman Rockwell Museum at Stockbridge

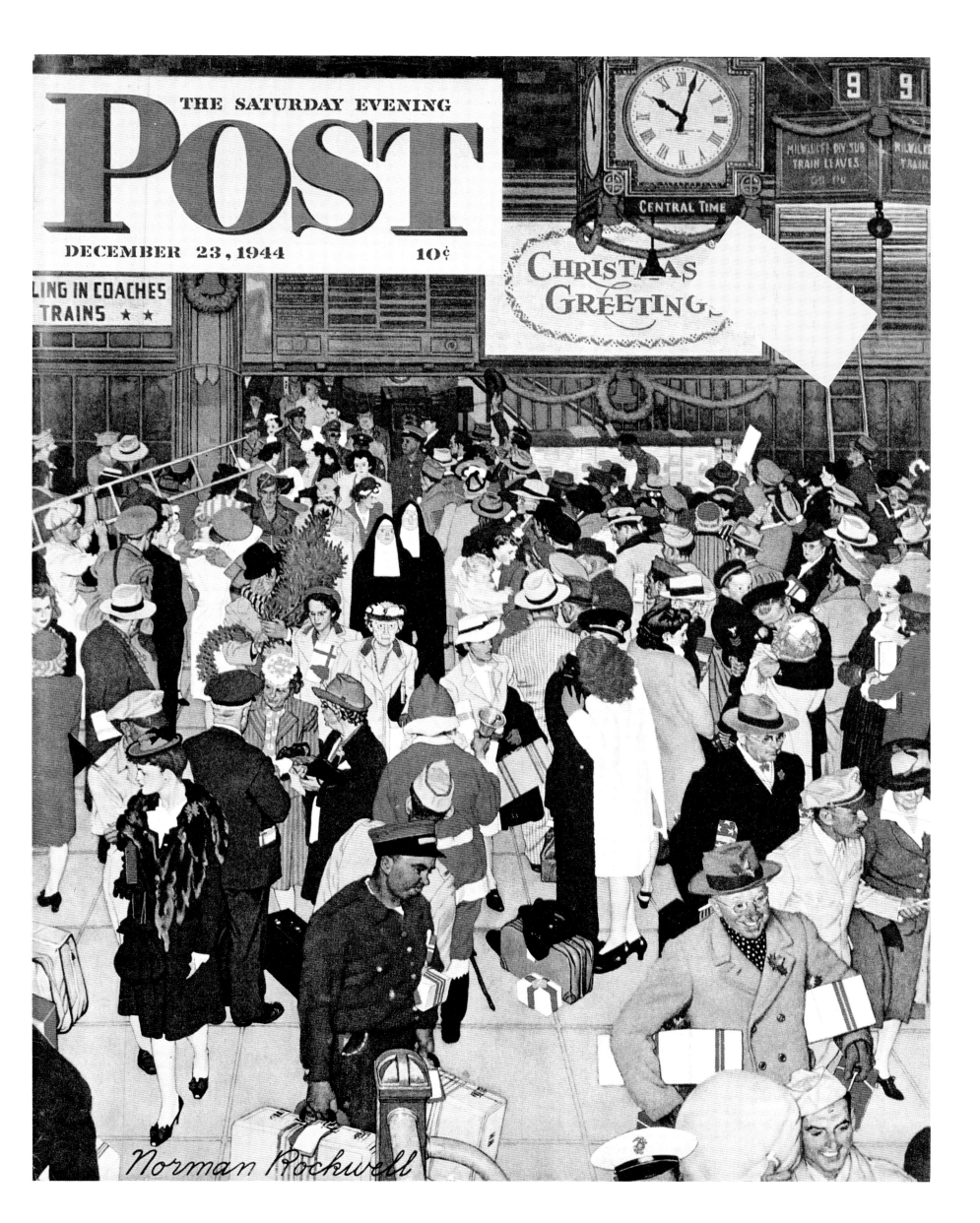

Rockwell always enjoyed painting scenes on a train, and this idea came to him while he was riding from New York to Vermont during the war. The warfront seems very distant to the servicemen on leave, and no thought of war enters the mind of the curious bystander peering over the back of the seat. To get the setting just right, Rockwell brought his photographer to a railroad car that had kindly been left for him in Arlington for two days by the Rutland Railroad; he used his neighbors as models. With Rockwell's love of detail, he inserted just enough information to identify two sailors at opposite corners and a member of the Army Air Corps in the center. He even gave the train conductor three hash marks on his sleeve for good measure.

LITTLE GIRL OBSERVING LOVERS ON A TRAIN
Saturday Evening Post cover
August 12, 1944
Photo courtesy The Norman Rockwell Museum at Stockbridge

THE SATURDAY EVENING
POST

AUGUST 12, 1944 10¢

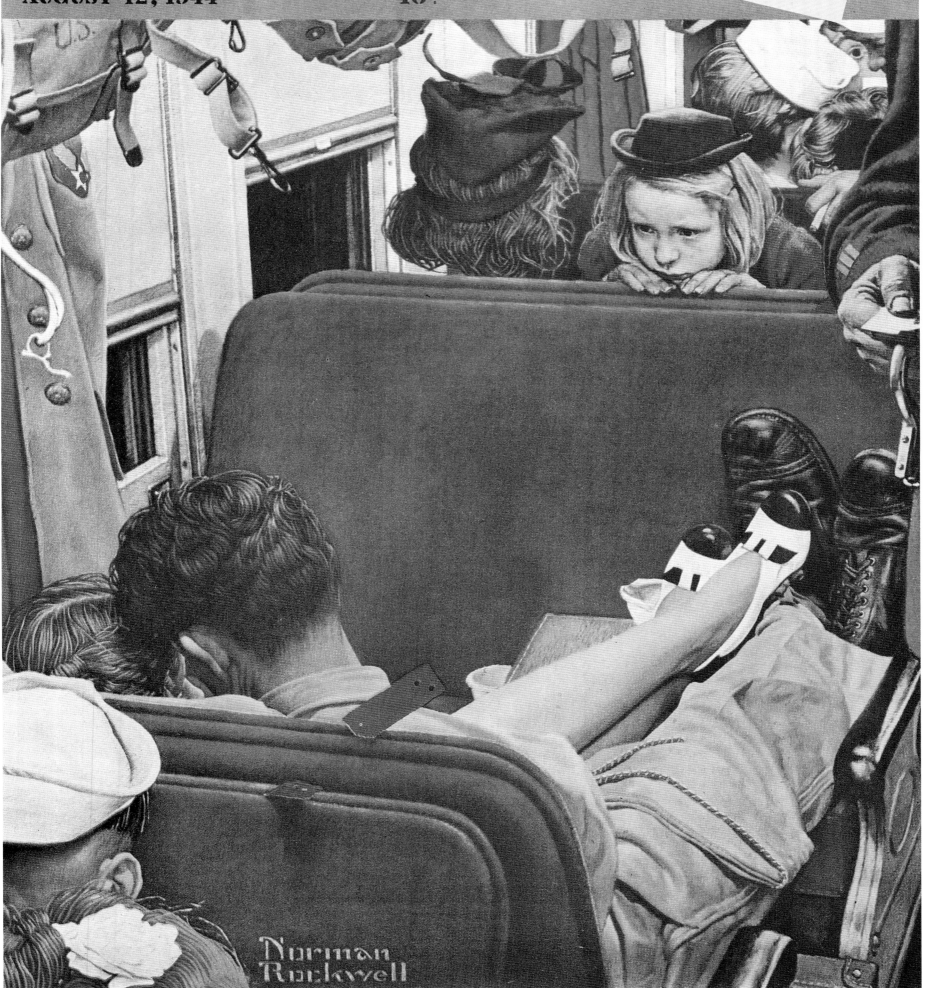

Pencil on paper
Whereabouts of original unknown
Photo courtesy The Norman Rockwell Museum
at Stockbridge

By 1945 American families were consumed with thoughts of returning soldiers. Five of Rockwell's *Post* covers that year—in May, September, October, November, and December—related to the subject of coming home, and taken as a group they represent a full range of expression, demonstrating his most mature work to date. The first in this group may be his most famous. More than 300,000 copies were placed on display when the U.S. Treasury selected it as the official poster for the eighth war-bond drive. The setting was Troy, New York, a nearby city from which Rockwell had frequently taken the train to New York City. Rockwell searched for two days before finding the right kind of backyard in a section of town located along the railroad tracks. He photographed the backyard on location, combining this with photographs taken in the studio of his neighbors from Arlington. On three windows he affixed the stars that indicated how many family members were serving their country. In the open doorway Rockwell inserted his own figure holding a pipe.

THE HOMECOMING

Original oil painting for *Saturday Evening Post* cover, 28" x 22"
May 26, 1945
Private collection
Photo courtesy American Illustrators Gallery/Judy Goffman Fine Art

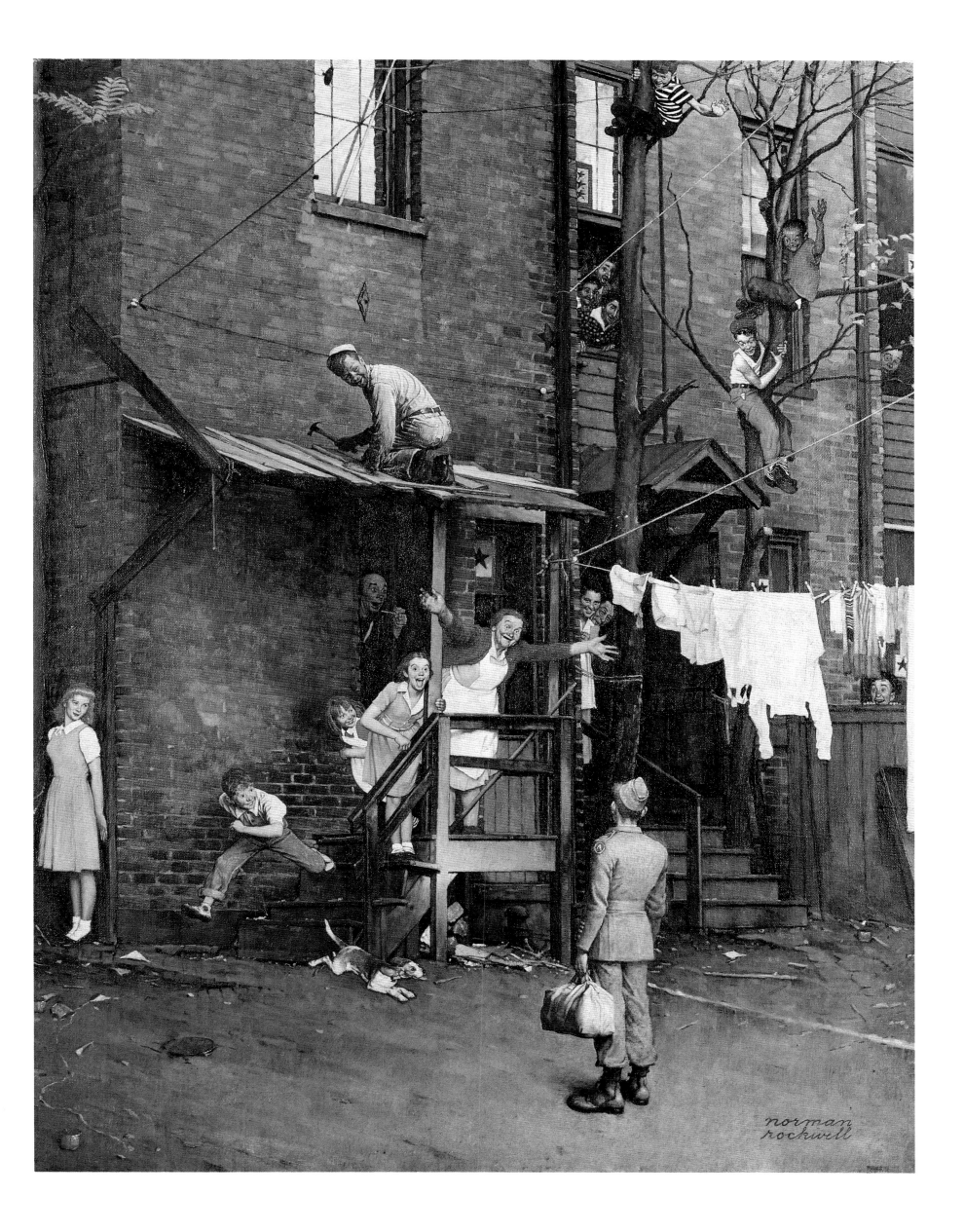

"A lot of returned sailors will soon be doing the kind of sack duty shown in Norman Rockwell's cover, gladly trading all the palm trees in the Pacific for the shade of one apple tree in their own yard at home," the *Post*'s editors remarked. They continued to describe the artist's working method, "Just to show you how artists work, however, let's disassemble this picture, now it's finished. The sailor goes back to the Navy—Rockwell borrowed him from Williams College. The sailor's blouse goes back to a shipmate—he borrowed that because his own had none of that fleet salad on the chest. Rockwell borrowed the dog from his son Tommy, borrowed the hammock from Mrs. Robert Smith, a neighbor. The house that shows is neither Rockwell's nor the sailor's; it belongs to another neighbor, 'Vic' Yalo. The shoes are Rockwell's own. He didn't have any cigarettes at the moment, and couldn't borrow any from the sailor, so the cigarettes are painted from memory."

HOME ON LEAVE
Saturday Evening Post cover
September 15, 1945
Photo courtesy The Norman Rockwell Museum at Stockbridge

THE SATURDAY EVENING POST

POST

SEPTEMBER 15, 1945 10¢

Berliners say:

"YOU CAN'T DO THIS TO US"

By ERNEST O. HAUSER

The Christian Science Monitor

By MARQUIS W. CHILDS

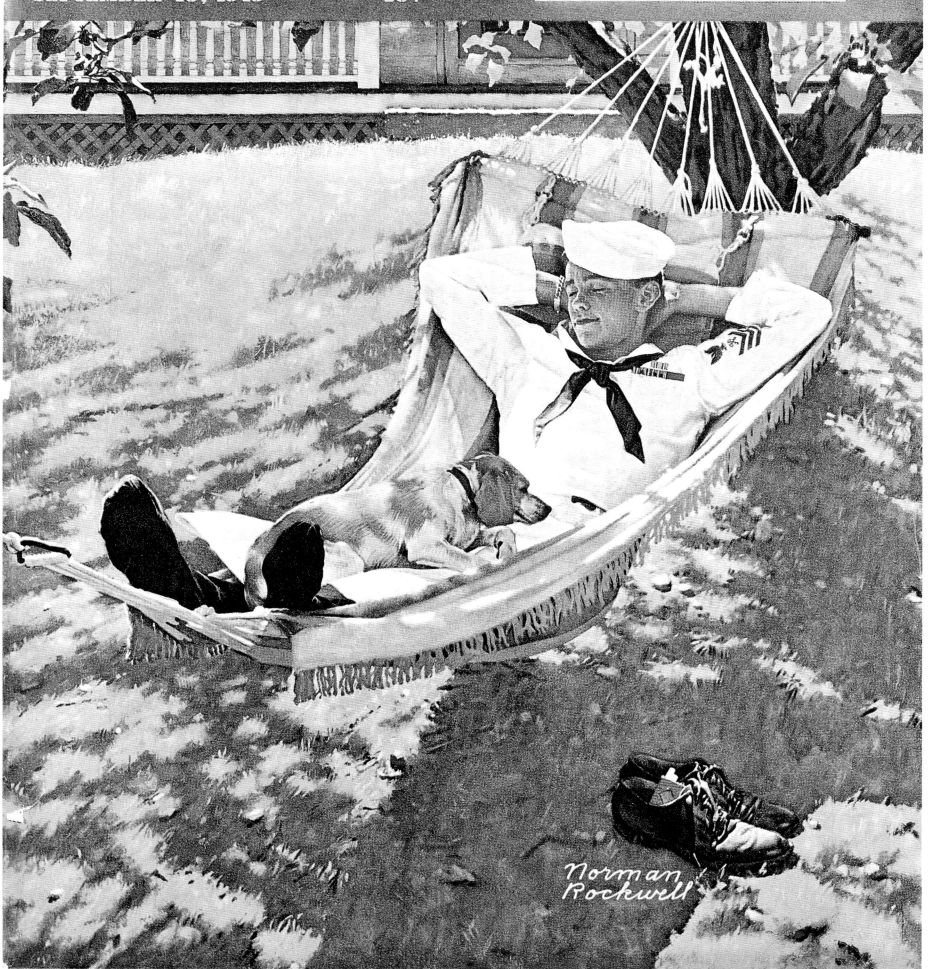

Norman Rockwell

Pencil on paper
Whereabouts of original unknown
Photo courtesy The Norman Rockwell Museum
at Stockbridge

In this large and tightly designed composition, Rockwell represented a more serious aspect of coming home. The neighbors are huddled around to catch every word of what the returning marine is saying. Although the newspaper article on the wall makes it clear that young Joe is a hero, evidently he is not boasting about his heroic feats, but sharing with his friends the more upsetting experiences of landing in Iwo Jima.

Wanting the scene to feel real, Rockwell selected Benedict's Garage as the setting, a familiar hangout in the neighborhood. Two of Rockwell's sons, Peter and Jarvis, posed as the young boys. "Everyone was real," remembers Peter. "This really was a dark, greasy garage. In fact, I think Pop actually *added* light to it for the painting." The gathering could have been as real as the interior of the garage, including the storyteller himself, who was a former marine discovered by Rockwell one evening at a Grange Hall square dance.

HOMECOMING MARINE
Original oil painting for *Saturday Evening Post* cover, 43" x 42"
October 13, 1945
Collection American Illustrators Gallery/Judy Goffman Fine Art
Photo courtesy American Illustrators Gallery/Judy Goffman Fine Art

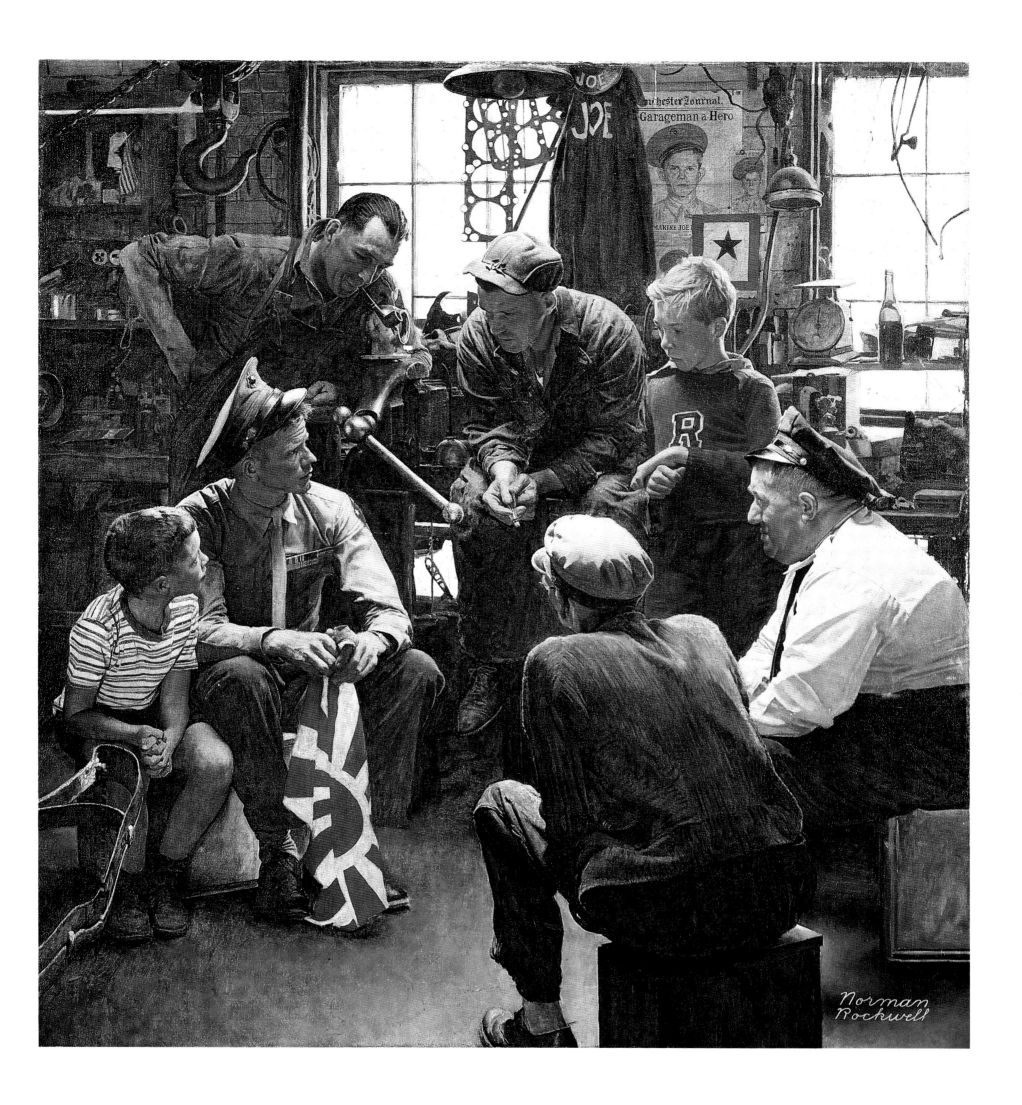

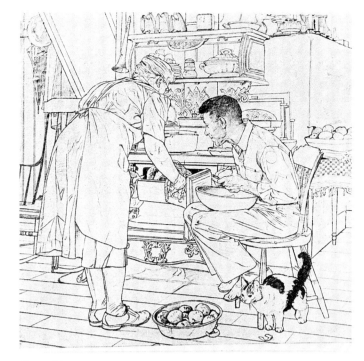

Pencil on canvas
Whereabouts of original unknown
Photo courtesy The Norman Rockwell Museum
at Stockbridge

For many Americans, Thanksgiving 1945 was once again a joyous family event. Anticipating that this would be a good year for a cover based on the idea of a soldier returning home for the holiday, Rockwell planned well in advance. On a trip to Maine during the summer, he located the ideal setting for a typical New England country kitchen, selected the models, tracked down a uniform from a veteran, shopped for props, brought in a photographer, and made dozens of photographs—all within a two-day period. Back in Arlington, he worked for many days on a series of sketches, referring to the photographs he had taken in Maine. But nothing seemed right: the model was too young, the perspective was wrong, the mother didn't look sufficiently old-fashioned. The entire composition was unsatisfactory to him. Time was running short as the *Post*'s deadline approached, but Rockwell decided to discard the entire concept and start over, using another setting and a fresh perspective. He selected two neighbors who seemed more appropriate, a mother and her son, a bombardier who had flown sixty-five missions over Germany.

**THANKSGIVING: MOTHER AND
SON PEELING POTATOES**
Original oil painting for *Saturday Evening Post* cover, 35" x 33½"
November 24, 1945
Private collection
Photo courtesy The Norman Rockwell Museum at Stockbridge

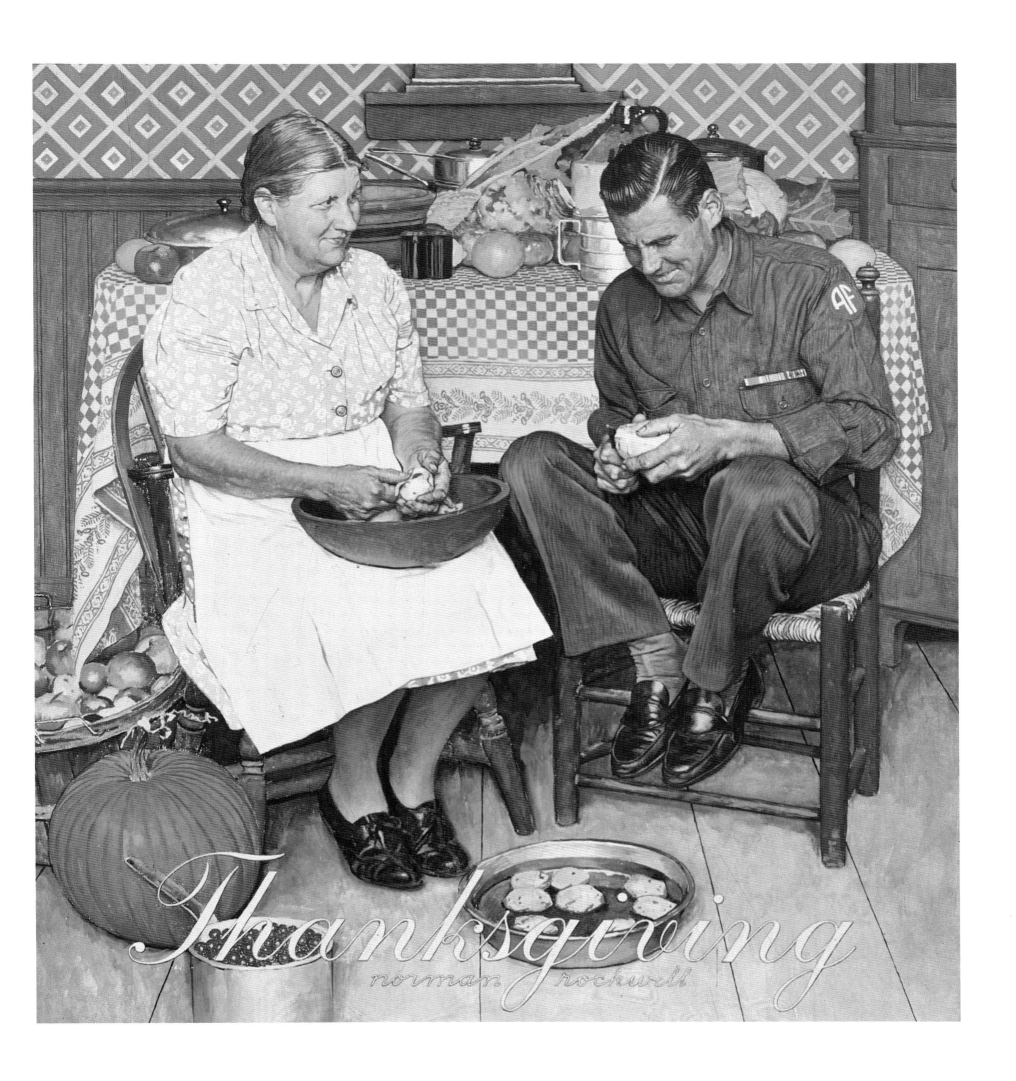

Thanksgiving

norman rockwell

By the end of 1945 Americans had already begun to look back on the war as history. Rockwell was looking back, too, but he focused on the positive changes that had occurred, and looked forward to a better future. As usual, Rockwell selected the most authentic model he could find. Art Becktoft had just come home. He'd been a Flying Fort pilot, was shot down over Germany, and spent many months in a prison camp. Lieutenant Becktoft squeezed into clothes that Rockwell had borrowed from a young boy. The uniform and duffel bag belonged to the model, still on "active duty," since Becktoff had decided to stay in the Army after all.

BACK TO CIVIES
Original oil painting for *Saturday Evening Post* cover
December 15, 1945
Whereabouts of original unknown
Photo courtesy American Illustrators Gallery/Judy Goffman Fine Art

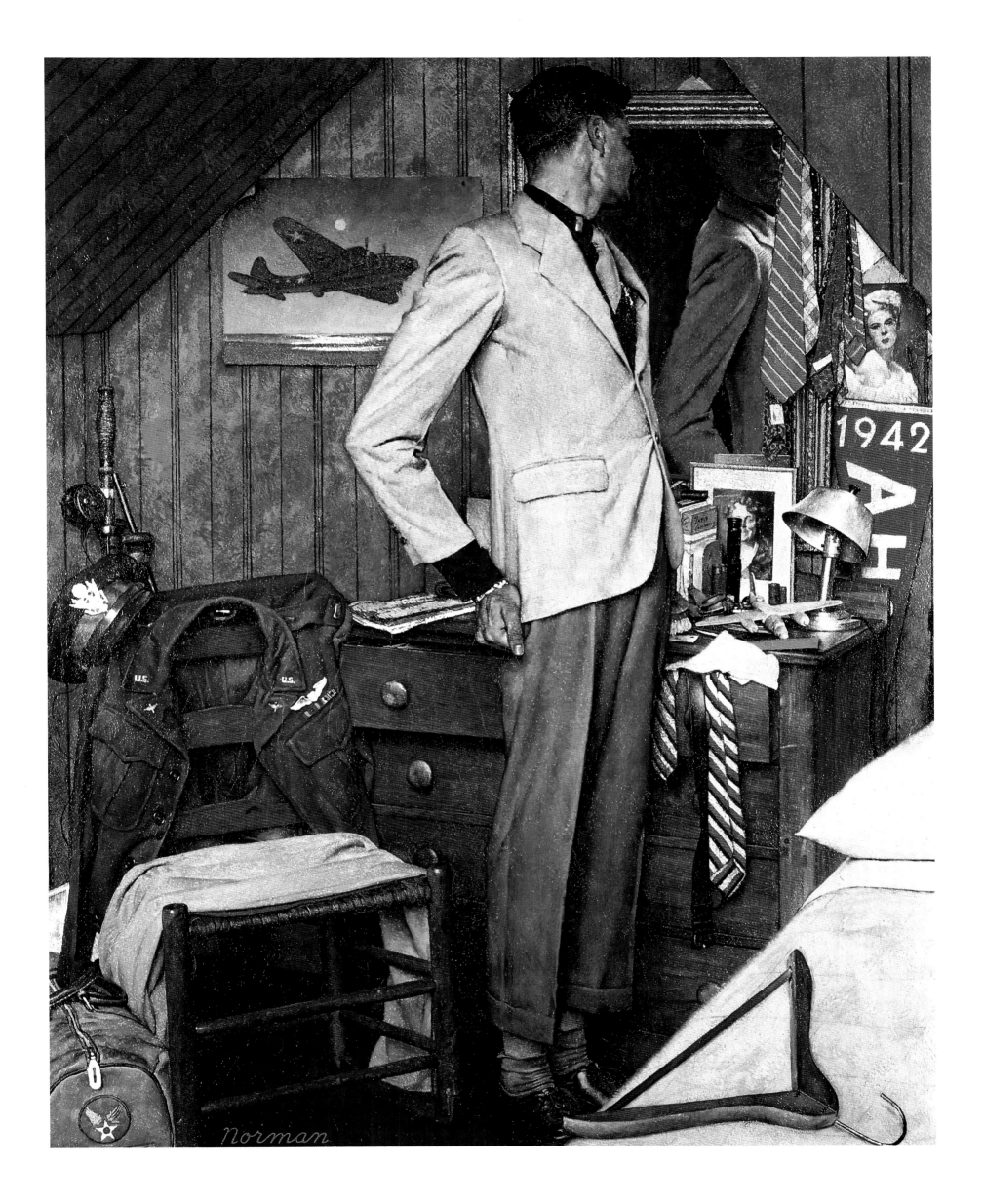

The Big Picture

Rockwell was by nature a peaceful man. The world he illustrated was the world he lived in—a small community of neighbors who greeted him on the street with a casual wave as they moved about their business. The millions who loved his work recognized themselves in the scenes he so lovingly rendered. He placed his subjects in familiar life experiences, creating a portrait of American life that is both idealized and real at the same time. This is the America he sought to preserve. The words *To Make Men Free*, the title of the book by Gene Gurney Rockwell that is illustrated here, summarized for him the meaning of World War II and earlier American wars. While he continued to divert the American public with amusing and touching scenes of everyday life, Rockwell also created enduring images that effectively assert the principles for which military action may be necessary.

TO MAKE MEN FREE
Original oil painting for cover of book of same title, 47' x 33"
1943
Collection U.S. Army Center of Military History
Photo courtesy United Services Automobile Association

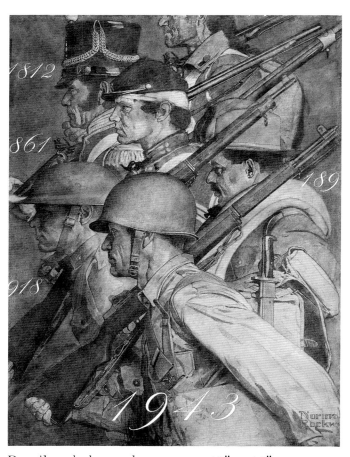

Pencil and charcoal on paper, 48" x 43"
Collection United Services Automobile Association
Photo courtesy United Services Automobile Association

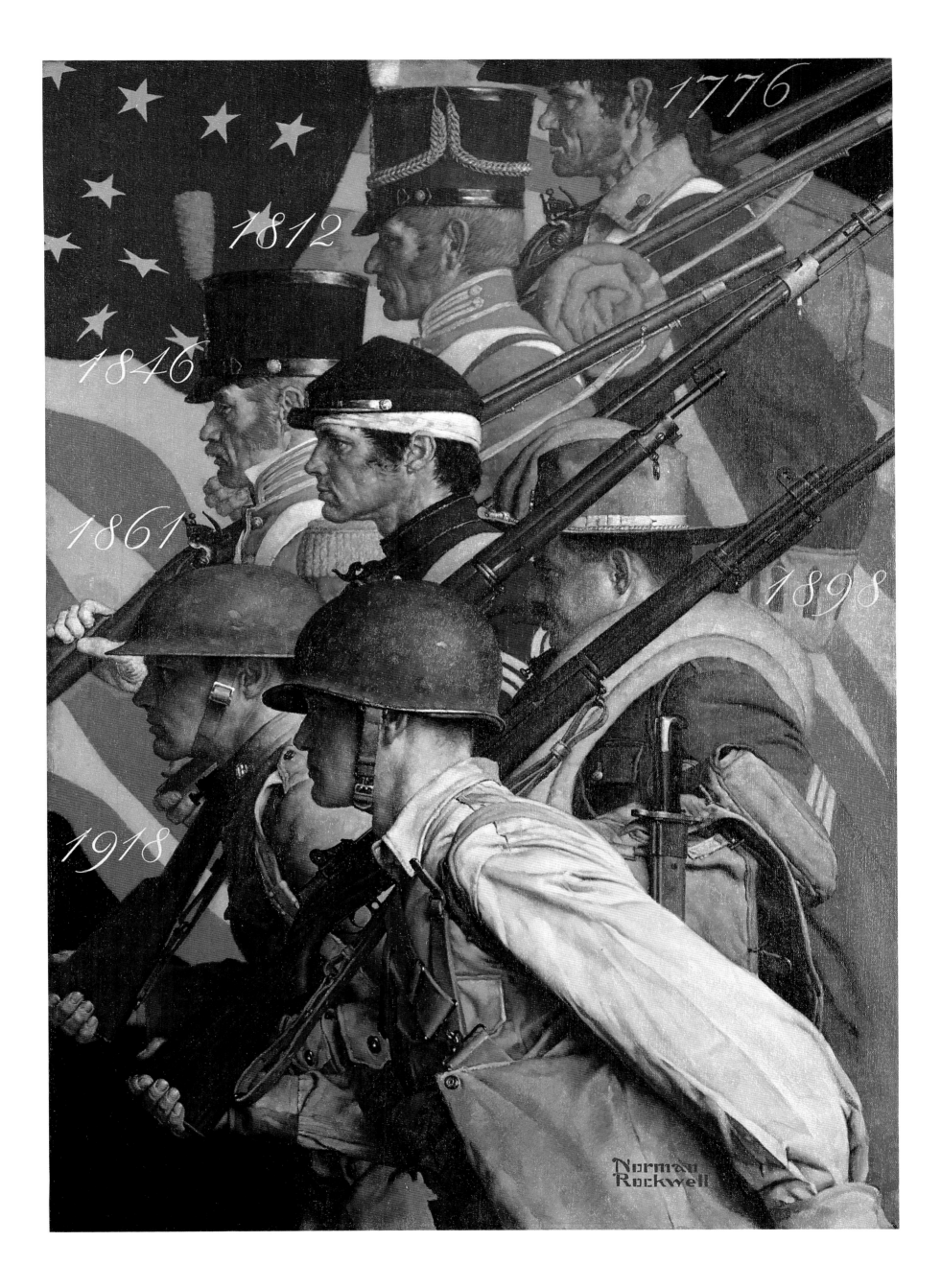

R ockwell began the series of the "Four Freedoms" with *Freedom of Speech*. In fact, it was this scene that inspired the entire series. Rockwell was struggling with a way to express the concept of the "Four Freedoms" that would be unpretentious, when he suddenly thought about a town meeting that he had recently attended in Arlington. He remembered how his neighbor Jim Edgerton stood up to speak his mind about the proposed construction for the new Arlington high school. Although no one agreed with his view, Edgerton continued to argue his point without being interrupted by dissenters. What better example was there of free speech in operation? Here was precisely the idea Rockwell was looking for in the "Four Freedoms": to convey the idea of fundamental freedoms within the context of everyday practice.

Rockwell started the painting over four times before he arrived at the final concept. In an earlier version, he placed all the figures sitting squarely around the central figure. But Rockwell felt there were too many people in the picture. "It was too diverse, it went every which way and didn't settle anywhere or say anything," he said. He shifted the view below eye level to create a more dramatic expression. To add interest to the composition, he placed his own eye in the upper left of the group.

FREEDOM OF SPEECH
Story illustration for *Saturday Evening Post*, 45¾" x 35½"
February 20, 1943
Collection The Norman Rockwell Museum at Stockbridge
Photo courtesy The Norman Rockwell Museum at Stockbridge

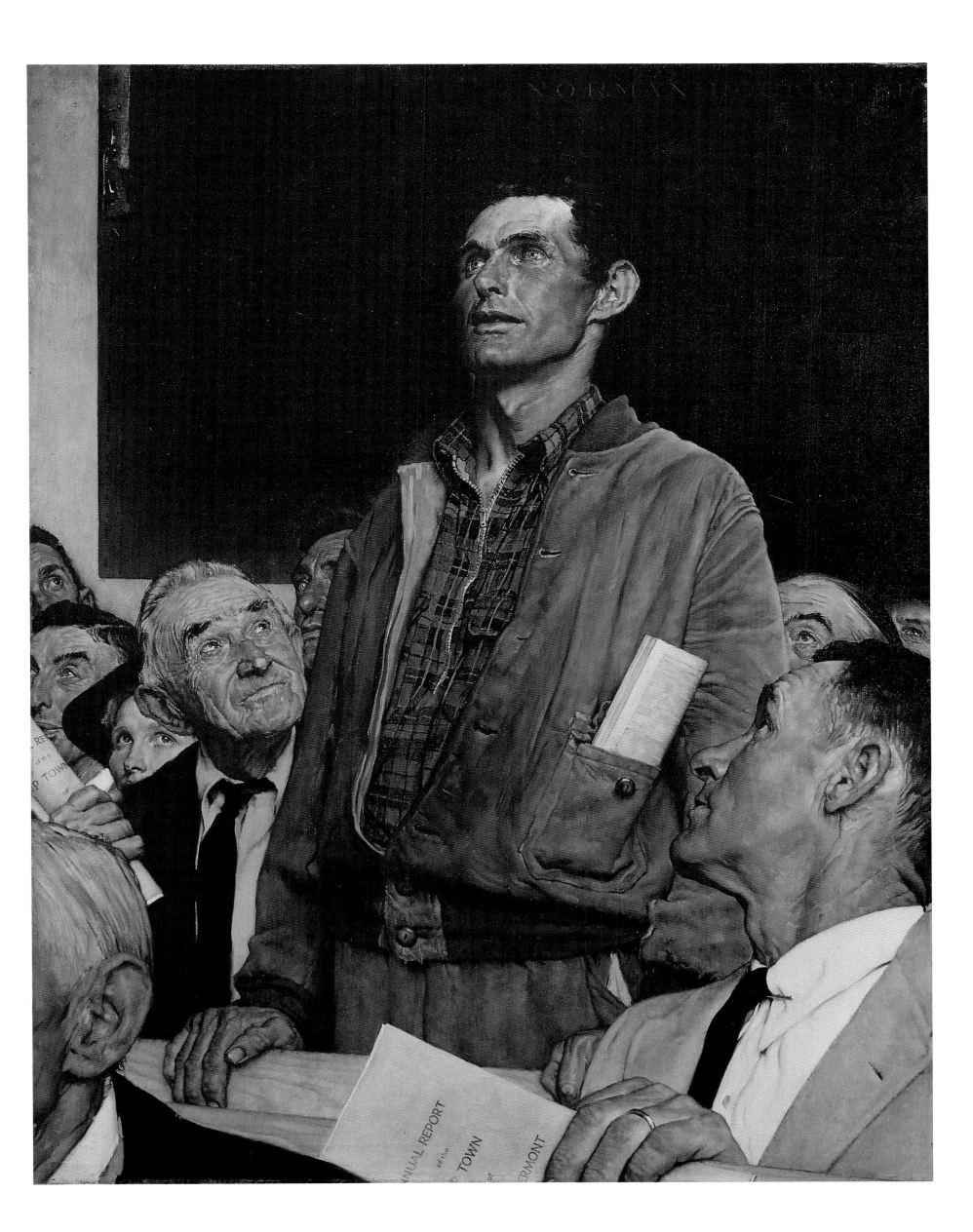

Preliminary idea for *Freedom of Worship*
Oil on canvas, 41" x 33"
Private collection
Photo courtesy American Illustrators Gallery/
Judy Goffman Fine Art

Oil and pencil on poster board with acetate
overlay
Private collection
Photo courtesy American Illustrators Gallery/
Judy Goffman Fine Art

Rockwell struggled with the second painting in the "Four Freedoms" series for two full months. Religion is "an extremely delicate subject. It is so easy to hurt so many people's feelings," he explained. At first he wanted to emphasize the idea of tolerance, creating a sketch of a Jew in a barber's chair being shaved by a man who is obviously a New England Protestant, while a black gentleman and a priest await their turns. He had almost completed the picture when he discarded it in favor of another idea based on the saying, "Each according to the dictates of his own conscience." He had heard the saying somewhere, but couldn't recall the origin. (In fact, the likely source was a phrase included in the "Thirteen Articles of Faith" by Joseph Smith, the founder of the Church of Jesus Christ of Latter Day Saints.)

FREEDOM OF WORSHIP
Story illustration for *Saturday Evening Post*, 46' x 35½"
February 27, 1943
Collection The Norman Rockwell Museum at Stockbridge
Photo courtesy The Norman Rockwell Museum at Stockbridge

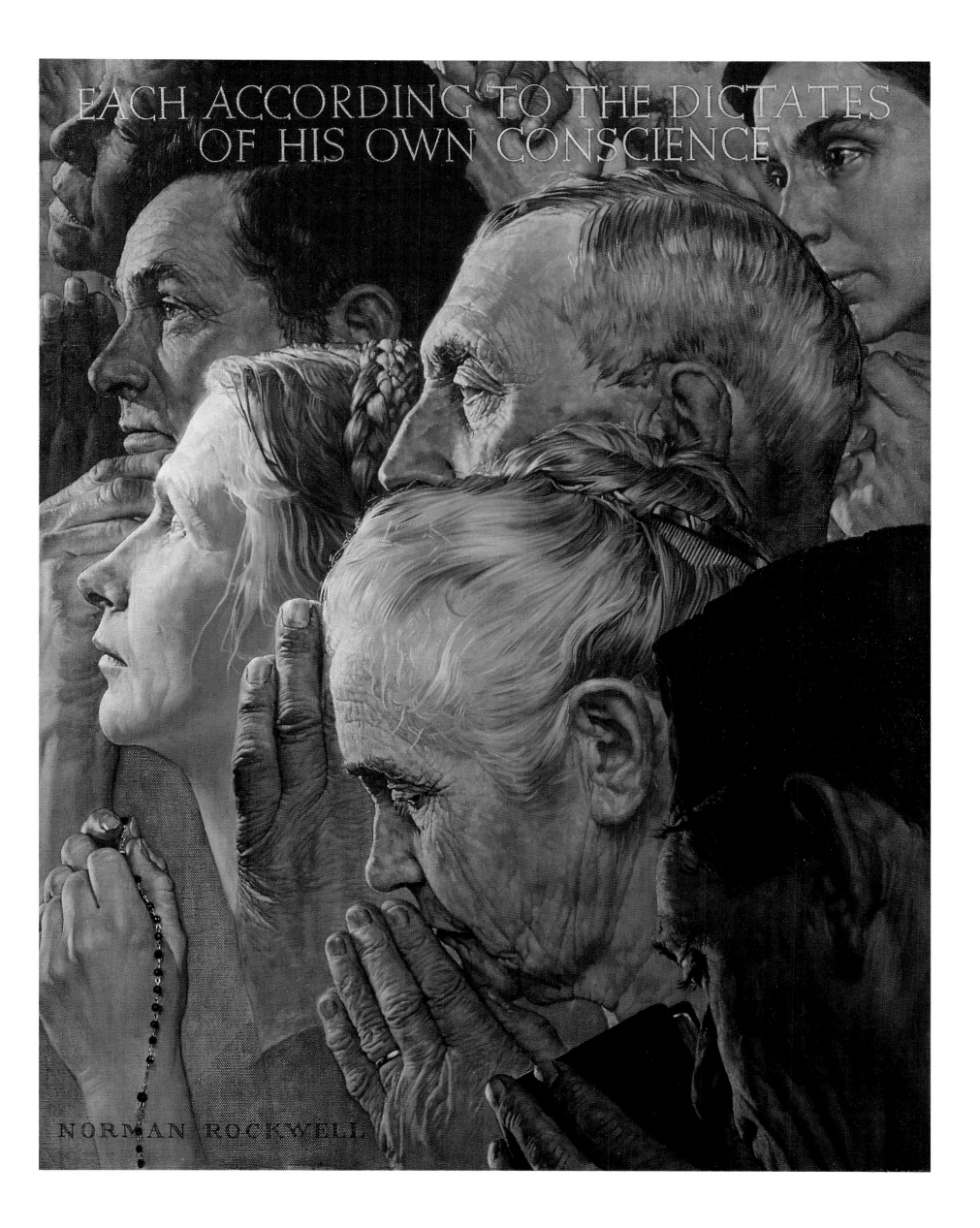

After painting *Freedom of Speech* and *Freedom of Worship*, Rockwell proceeded easily with the next two freedoms. On Thanksgiving Day he photographed his cook, Mrs. Wheaton, as she presented the turkey to the family at the table. She "cooked it, I painted it, and we ate it," Rockwell reported. "That was one of the few times I've ever eaten the model." In addition to the family cook, the artist also included two Rockwells in the picture—Rockwell's wife, Mary, on the left and his mother on the right.

In his autobiography Rockwell admitted that he never cared for this painting, any more than he liked *Freedom from Fear.* "Neither of them has any wallop," he remarked. *"Freedom from Want* was not very popular overseas. The Europeans sort of resented it because it wasn't freedom from want, it was overabundance, the table was so loaded down with food. I think the two I had the most trouble with—*Freedom of Speech* and *Freedom of Worship*—have more of an impact, say more, better."

FREEDOM FROM WANT
Story illustration for *Saturday Evening Post,* 45⅞"x 35½"
March 6, 1943
Collection The Norman Rockwell Museum at Stockbridge
Photo from war-bond poster, courtesy United Services Automobile Association

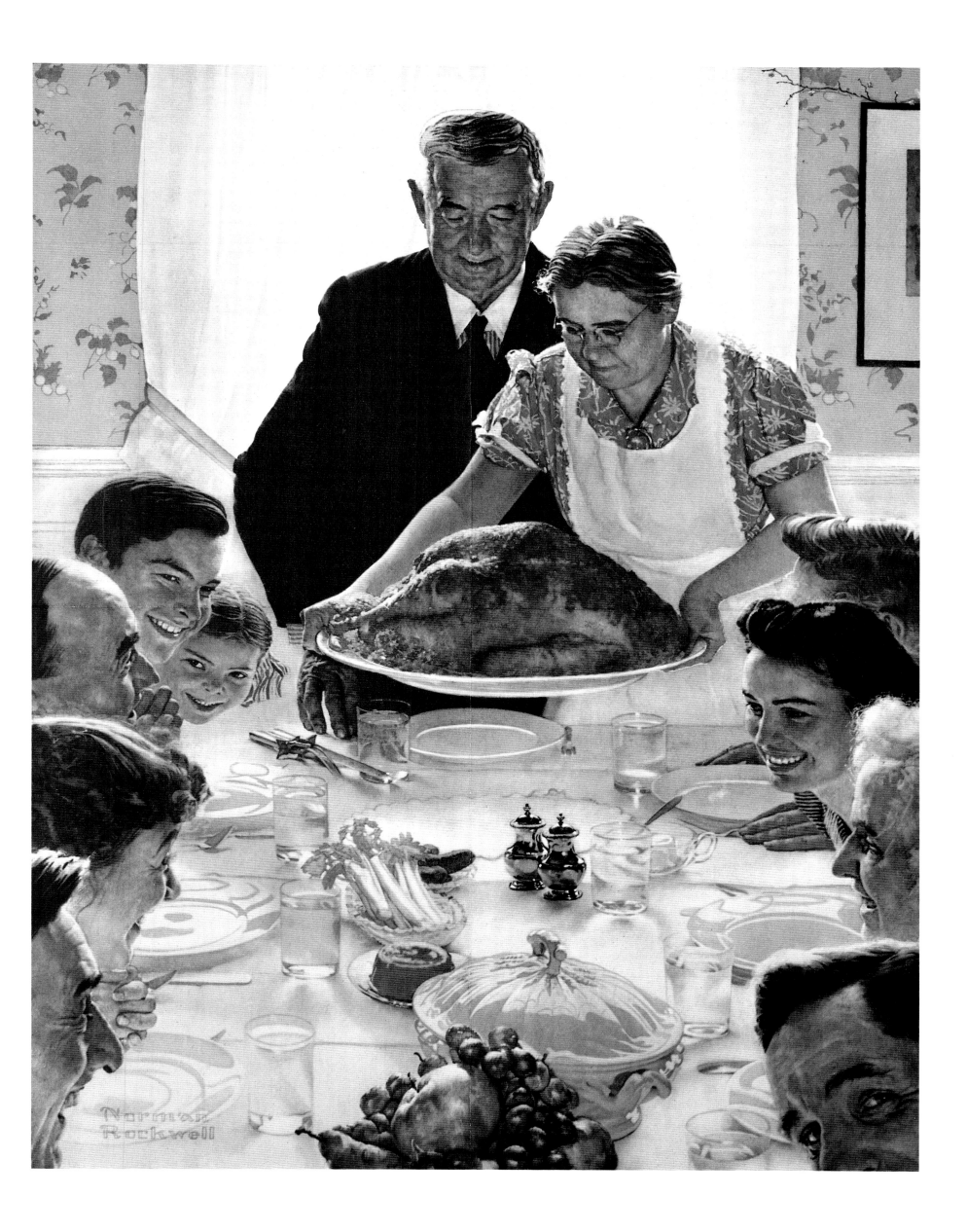

The last of the "Four Freedoms" was painted during the bombing of London. In retrospect, the self-critical Rockwell suspected that the idea of the painting ("Thank God we can put our children to bed with a feeling of security, knowing they will not be killed in the night") was too smug. But few would have agreed with the artist's tough assessment. This painting, like the other three in the series, gave a tremendous lift to American morale during a critical point in the war. It was Rockwell's gift that he could translate into positive terms the very principles for which the war was being fought. For the painting Rockwell selected his neighbors, Jim Martin (who actually appears in all the "Freedom" paintings), Mrs. Edgar Lawrence, and the two children of the local carpenter, Walt Squires.

FREEDOM FROM FEAR
Story illustration for *Saturday Evening Post*, 45⅜" x 35½"
March 13, 1943
Collection The Norman Rockwell Museum at Stockbridge
Photo courtesy The Norman Rockwell Museum at Stockbridge

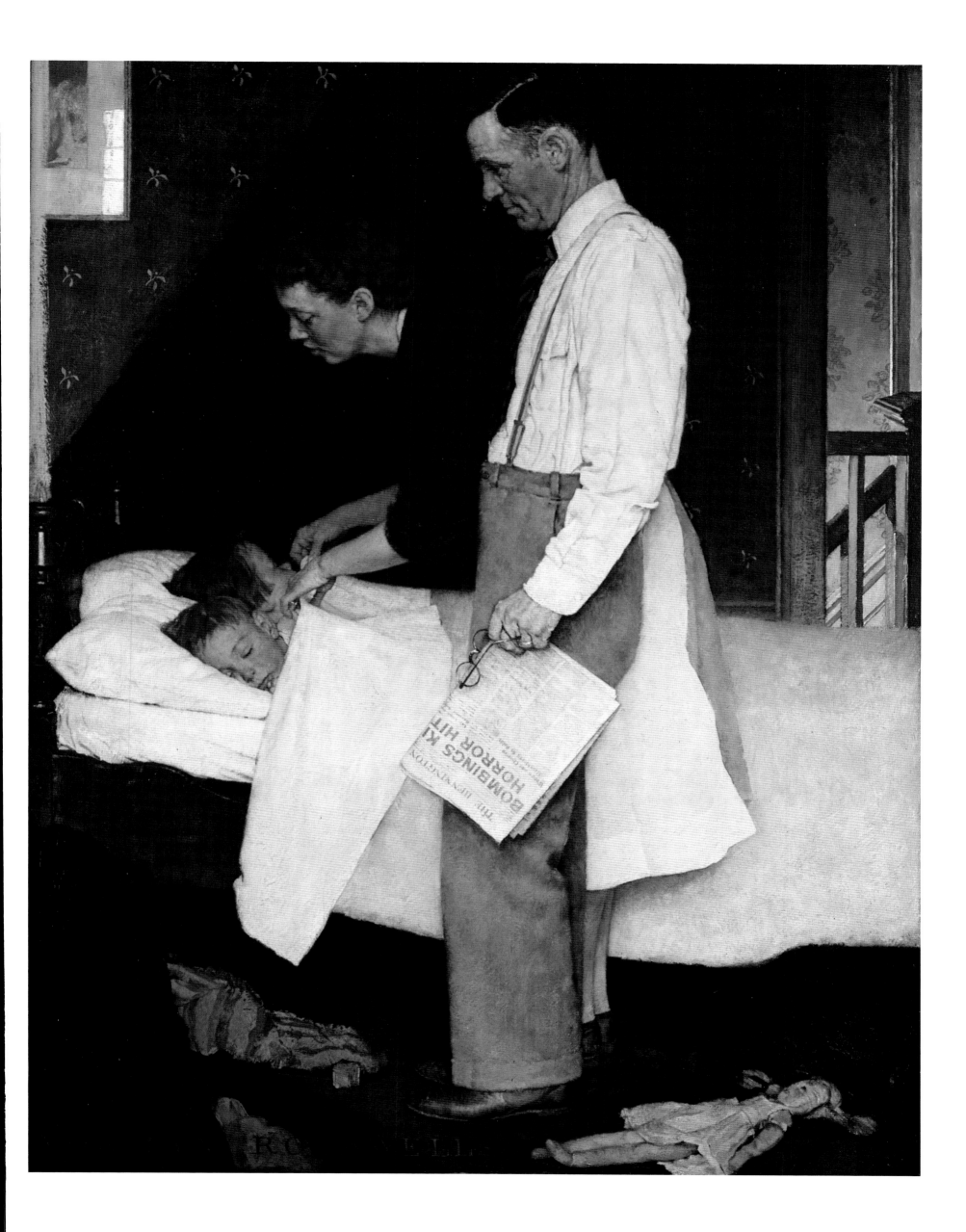

When the *Post* asked him to illustrate a story written by the poet Carl Sandburg commemorating Abraham Lincoln's birthday, Rockwell took the opportunity to reflect upon the meaning of the war now nearing its end. So many lives had been lost, so many sacrifices made, and toward what end? Taking Abraham Lincoln as a symbol of freedom and union, Rockwell created a powerful painting that affirmed the fundamental principles for which the war had been fought. The work stands as one of Rockwell's most eloquent statements. From the upper left Abraham Lincoln looks down upon the figure of a disabled soldier. Surrounding the soldier are symbols representing the principles of liberty that lie at the foundation of democracy in America: a safe harbor for immigrants throughout the world, where freedom from oppression extends to all races and creeds, where freedom of worship is an inalienable right, where education is universal. Hanging from the cross are dog tag and helmet, the sacrifices made to guarantee these freedoms. What lies in the future is the rebuilding (represented by the figure holding blueprints and a square), the hope for enduring peace, for a world in which these sacred principles will endure for all people.

THE LONG SHADOW OF LINCOLN
Original oil painting for *Saturday Evening Post* story, 54¼" x 41¾"
February 10, 1945
Collection The Lincoln Memorial Shrine and Museum, Redlands, California
Photo courtesy United Services Automobile Association

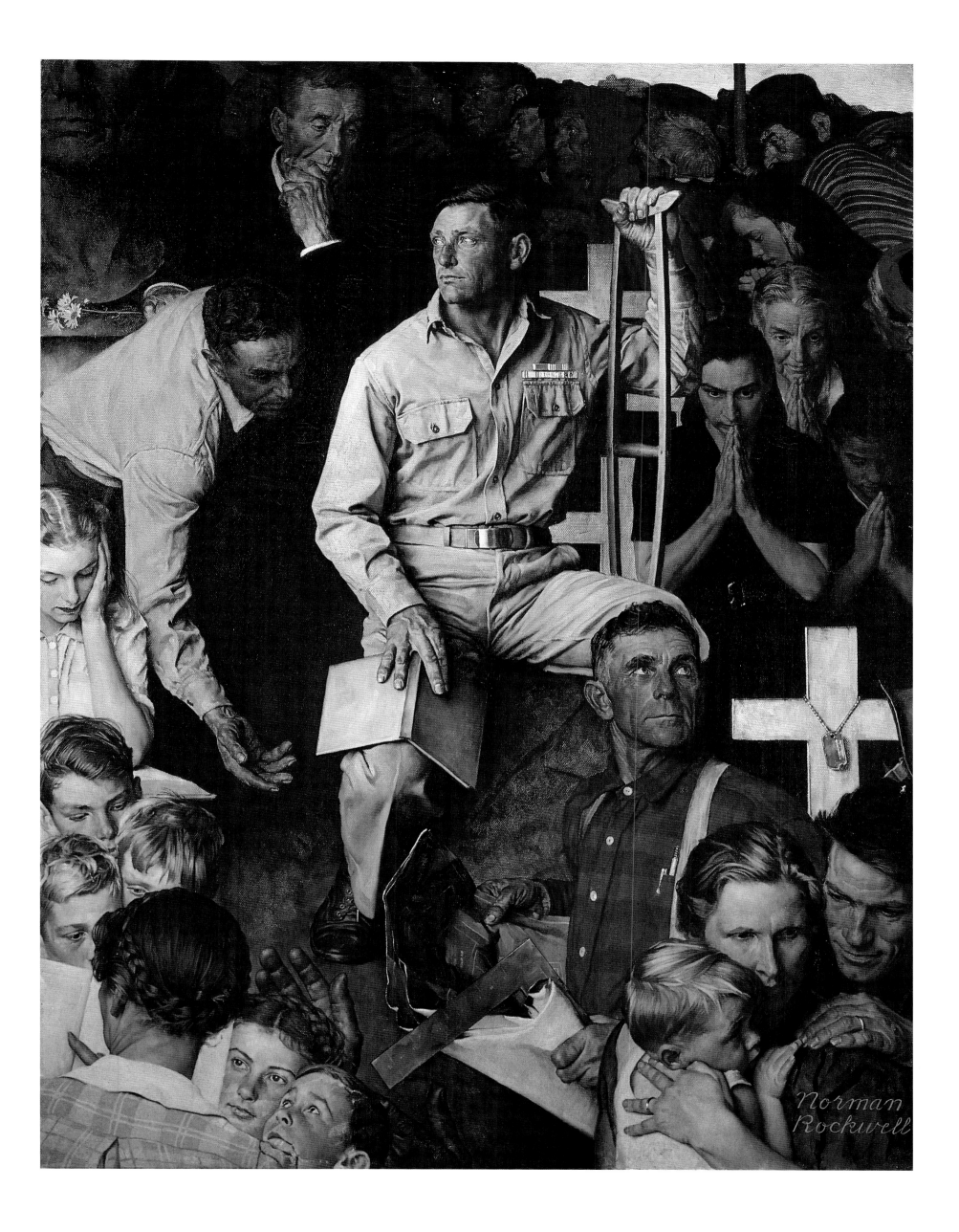

Susan E. Meyer was editor of *American Artist* magazine from 1971 to 1979. She first met Norman Rockwell in 1976, when she commissioned the illustrator to paint a cover for the bicentennial issue of the magazine, an assignment that represented his last magazine cover. A year after Rockwell died, Meyer was given access to the Rockwell files to create a book about the artist and his models, called *Norman Rockwell's People*, which was published in 1981 by Harry N. Abrams, Inc. She has written numerous books on illustration and design, including *America's Great Illustrators, James Montgomery Flagg*, and *A Treasury of the Great Children's Book Illustrators*. She recently completed a book on Mary Cassatt for young adults.

Robert F. McDermott is a retired Air Force brigadier general. Since 1969 he has been chief executive officer of United Services Automobile Association (USAA), a financial services company serving primarily military officers and their families. A graduate of West Point, McDermott flew fighter planes in World War II, earned an MBA from Harvard, and taught economics at West Point. When he was promoted to brigadier general in 1959, he was, at thirty-nine, the youngest flag-rank officer then on active duty in the armed forces. He served for fourteen years at the Air Force Academy, where he was dean of faculty for the first ten graduating classes. In 1989 the USAF Academic Excellence Chair was established in his honor at the Air Force Academy. McDermott was recently inducted into the American National Business Hall of Fame. He is the father of five and grandfather of thirteen.

Project Director: Debra Peacock

Creative Consultant: Patricia Van Hoecke

Project Editor: Sue Heinemann

Design: Brian Sisco, Leah Lococo at Harakawa Sisco Inc.

Production: Giga Communications, Inc.

Color Separations: Reprocolor Llovet, Barcelona

Printed and Bound by The John D. Lucas Printing Company, Baltimore

A Roundtable Press Book